The Great
CHICAGO
BEER RIOT

HOW LAGER STRUCK A BLOW FOR LIBERTY

JOHN F. HOGAN & JUDY E. BRADY

Published by The History Press
Charleston, SC
www.historypress.net

Copyright © 2015 by John F. Hogan and Judy E. Brady
All rights reserved

First published 2015

Manufactured in the United States

ISBN 978.1.46711.890.3

Library of Congress Control Number: 2015948353

Notice: The information in this book is true and complete to the best of our knowledge. It is offered without guarantee on the part of the authors or The History Press. The authors and The History Press disclaim all liability in connection with the use of this book.

All rights reserved. No part of this book may be reproduced or transmitted in any form whatsoever without prior written permission from the publisher except in the case of brief quotations embodied in critical articles and reviews.

In memory of our parents:

Vivienne E. Cooper Brady Liddell and Raymond I. Brady

Cecilia Buckley Hogan and Francis J. Hogan

CONTENTS

Preface	7
Coming to America	11
What Else They Found	29
Gemultlichtkelt und Politik	47
The Little Giant Stands Tall	57
"Pick Out the Stars"	67
Lager's Legacy	87
Bibliography	105
Index	107
About the Authors	111

PREFACE

In the 2012 work *Fire Strikes the Chicago Stock Yards* (The History Press), Alex Burkholder and John wrote, "Fire, as much as meat packing, railroads, hardball politics or icy blasts off Lake Michigan, has defined the evolution of the city." The same could be said about beer, so now, in a small way, that's what we're attempting to do.

A number of fine books and articles have been written about Chicago's history of beer brewing and drinking. Ours is an attempt to show beer and drinking in general as a catalyst for historic sociopolitical changes already in the making. Many associate beer and Chicago with Prohibition—the Jazz Age, speakeasies, Al Capone and rival gangsters battling with machineguns over distribution territories. This is part of the city's history, to be sure, a story that's been told many times—perhaps too many. Our narrative goes back one hundred years earlier to about the time when Chicago's first full-scale commercial brewery, started by German immigrants William Haas and Conrad Sulzer, began operation. This happened in 1833, the year Chicago became a town. Before then, thirsty early settlers had to depend on one or two primitive taverns that made their own ale.

Over the next two decades, saloons began popping up everywhere until they outnumbered churches seventeen to one. The arrival of the ethnic drinking establishment in the mid-nineteenth century represented something new: a place where immigrants could gather among their own kind, away from the suspicious eyes of the native-born establishment, which disliked and distrusted them. The neighborhood saloon was particularly dear to the

Preface

German community. It offered a social club, a gathering place for neighbors and a link to the old country. When the city's prohibitionist administration chose to ban the sale of beer and other alcoholic beverages on Sunday, the worker's only day off, it was felt that the ruling class had gone too far.

The riot that followed, we suggest, was not an isolated incident but rather the culmination of tensions long in the making. The late 1840s unleashed a confluence of forces that directly or indirectly provoked the Lager Beer Riot. German and Irish immigrants began pouring into the city, many of the former fleeing the failed Revolution of 1848 and many of the latter escaping the famine of 1846–48. They brought their thirst with them, much to the displeasure of an openly hostile ruling class.

Also in 1848, the prohibitionist and women's suffrage movements gained new momentum following a historic gathering at Seneca Falls, New York. The two campaigns sometimes moved in lockstep to protect family life against the sorrows inflicted by alcoholism. By the mid-1850s, support for prohibition was rapidly gaining strength in Illinois and other northern and eastern states. Finally, in the last few years before the outbreak of the Civil War, passions over the slavery question were near boiling. U.S. Senator Stephen A. Douglas of Illinois, who sought compromise on the issue, came close to getting manhandled when he addressed a hostile audience. The city definitely was on edge by April 1855, when Mayor Levi Boone made his ill-advised decision to ban the sale of alcoholic beverages on Sunday.

Not long after the riot had ended, Chicago was on its way to forming a modern police department. Prohibition and the anti-immigrant Know-Nothing Party fell into decline. New ethnic and political coalitions began to take shape, and the realignments energized the young Republican Party, helping to send a somewhat obscure Illinois politician named Abraham Lincoln on a path to the White House.

A number of stalwarts—"gluttons for punishment," as author John Hogan's late mother would have called them—re-upped for duty on this project.

A big thank-you goes to previous co-author Alex Burkholder, who contributed his graphic arts skills along with his knowledge of early Chicago. The talents of well-known Chicago artist Matthew Owens are on display at several junctures. Author Carla Owens, Matthew's spouse, provided invaluable assistance. And a huge helping of thanks to talented writer and editor Andrea Swank for compiling the index.

Several divisions of the Chicago Public Library system distinguished themselves as usual. Foremost were Lyle Benedict and his staff at the

Preface

Municipal Reference Collection. Their colleagues at Special Collections and Preservation, along with those at the Conrad Sulzer Regional Library's North Side Neighborhood History Collection, provided invaluable help selecting many of the images that photo pro Charles Ezaki readied for publication.

The staffs at the Chicago History Museum and Newberry Library were always ready to help, as they have been through three previous endeavors. Our neighborhood library, the John Merlo Branch, once again offered a welcoming retreat for writing, away from cellphones and other distractions of daily life.

History Press project editor Ryan Finn offered many improvements to these pages and was a pleasure to work with. (Please don't flunk us, Ryan, for ending a sentence with a preposition.) One final tip of the cap goes to Senior Commissioning Editor Ben Gibson, whose support and wise counsel have sustained us every step of the way.

COMING TO AMERICA

Unlike many of their countrymen before and after, a significant number of German and Irish immigrants who arrived in Chicago and other U.S. cities in the late 1840s and early 1850s were motivated by fear more than the universal promise of American life. They were running away from something more than toward any shining city on a hill. Often they fled with few belongings, desperate to escape disease, death, repression, arrest and imprisonment. Some were literal fugitives, including jail escapees. All were refugees. "Anywhere but here" became their mantra.

Europe in 1848 saw itself engulfed in a wave of uprisings against the monarchial power structures left in place after the 1815 Congress of Vienna reconfigured the continent in the wake of the Napoleonic Wars. It was as if the spirit of the French Revolution had lain dormant for more than five decades and then experienced a reawakening among peoples grown restive under the rule of kings, princes, emperors and sundry potentates. Revolts began in January 1848 in Sicily and southern Italy and spread to France the following month. Austria, Belgium and Switzerland became swept up in the rise against the old autocratic order. Even Ireland, ravaged by famine since 1845, experienced a brief, futile rebellion against the British Crown.

The revolutionary fervor reached Germany in March, when "a flood of meetings and demonstrations organized by the middle class, supported by peasants, artisans and workers, swept the leaders of the liberal opposition into power" in Bavaria, Hanover, Saxony and other regions, according to Golo Mann in *The History of Germany Since 1789*. Germany at the time was

a mere geographical expression, a collection of smaller states, each with its own governing system. The goal of the insurgents was the establishment of a unified democratic nation without resort to the guillotine. Theirs was to be a bloodless revolution—or, to invoke a latter-day expression, a "green revolution." This was not the France of 1789; there was no corrupt, self-indulgent *ancien regime* waiting to be toppled. In fact, the German provinces, on the whole, were well governed—but from the top down.

Precisely because of its humane nature, the German Revolution of 1848–49 failed. Only seventy-five-year-old Prince Metternich, his glory days of helping defeat Napoleon long past, abdicated his position of authority. A few severed heads might have intimidated other power figures who remained and initially granted concessions to the insurgents as they waited to see how the endgame would play out.

An elected national assembly convened in May at Frankfurt and organized a provisional government to serve while the drafting of a constitution went forward. The delegates grappled with the unification issue into the fall. "The German liberals wanted a thorough political change," Mann wrote, "but without the rough means employed for the purpose by other countries, because above all they hated lawlessness." They got it anyway. Serious street fighting broke out in Berlin between civilians and the army. Several hundred were fatally shot. A split divided moderate and radical revolutionaries. A radical republican named Frederich Hecker, convinced that nothing could be accomplished in Frankfurt, led a failed uprising of some six thousand that Mann described as "a senseless, melodramatic venture." (Hecker fled to the United States; bought a farm near Belleville, Illinois, across the Mississippi from St. Louis; and fought for the Union in the Civil War.)

A fresh revolt in Austria was suppressed in blood and its leaders executed. To many, order was beginning to look more appealing than the messy business of introducing liberal democracy, and the despots who had never relinquished real control were all too glad to impose such order. "Had the will been there, the Parliament might have started by organizing a national army, as Cromwell had done," according to *The Forty-Eighters*, edited by A.E. Zucker. "But somehow these lofty spirits had no passion to destroy that which stood in their way; they did not seem to know their enemies."

One of those enemies was Prince William of Prussia, arch-conservative brother of the mentally unstable King Frederick William IV; the prince rode into this breach at the head of an army that put a brutal end to the extended "German Spring" in May and June 1849. Summary executions followed.

How Lager Struck a Blow for Liberty

"The German Revolution had wanted to be different from other revolutions," historian Mann wrote, "friendly, tolerant, legal; it suffered for it by ending in an interminable chain of treason trials…Several thousand fine speeches, several thousand dead and several thousand trials—such was the harvest of 1848 and 1849. Of the great hopeful turmoil nothing but disappointment, shame and derision seemed to remain." The losers fled, most to America, leaving homes, other property, jobs and social positions behind.

The number of emigrants from all of Germany rose from about 100,000 per year to 250,000 annually after 1849. Baden, a liberal stronghold in the southeast, saw at least 80,000 depart, more than 5 percent of the population. The exodus from that region was accelerated by a systematic campaign to purge political dissenters. "Local and state governments encouraged the dissatisfied, the troublemakers, the agitators, the failures and the paupers to leave, and aided them in making a speedy exit," noted Carl Wittke in *Refugees and Revolution*. Often an accused miscreant could obtain a pardon if he agreed to leave with the understanding that he'd be returned to custody if he dared to come back.

Germans and Irish composed the largest number of immigrants who reached America in the nineteenth century, with the Germans holding the edge. Official figures show that more than 950,000 Germans arrived between 1851 and 1860, with the Irish accounting for a little less than 915,000 for the same period. Chicago's ethnic makeup reflected a similar pattern. Between 1850 and 1860, the city's population leaped from 28,000 to just over 109,000. The German segment rose from about 5,000 to more than 22,000, while the number of Irish went from more than 6,000 to nearly 20,000. In other words, nearly 40 percent of Chicagoans in 1860 could trace their roots to Germany or Ireland.

The Forty-Eighters who reached America represented virtually every walk of life, from farmers and laborers to artists and teachers. Without question, Germany lost some of its best and brightest, although their numbers represented only a small minority of total German immigration at midcentury. The group included large numbers of Lutherans and Catholics but also many who came to represent the image or stereotype of the Forty-Eighter in the eyes of their hosts and even some German American historians. This newcomer was young, male, single, long-haired, bearded, flamboyantly dressed and a free-thinker, if not an atheist; he was also a believer in personal freedom, a cosmopolitan lifestyle and the superiority of Western civilization. Except for their Euro-centrism, they didn't seem terribly different from some American and European youth of the 1960s.

The Great Chicago Beer Riot

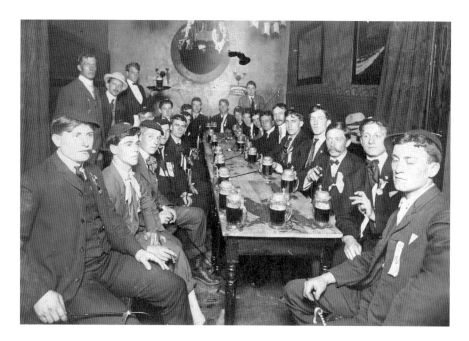

Chicago's German Americans enjoyed few things better than to gather over frothy mugs, particularly on Sundays, the nineteenth-century worker's only day off. *Courtesy of Conrad Sulzer Regional Library, Chicago Public Library, North Side Neighborhood History Collection, RLV, CC 4.3.*

The extreme anti-clerical wing of this substratum rubbed their conservative countrymen and American neighbors the wrong way. Held in particularly low esteem were the "bums of the revolution," as Wittke described them—those who refused to work because they felt it beneath them and who lazed about, perhaps discoursing on the philosophies of Hegel, Fichte and Kant. The more radical Forty-Eighters, according to historian Wittke, "alarmed Americans by their belligerence and tactlessness with which they challenged sacred and social customs of the Republic." Some were considered a bit too vocal in expressing their belief in the superiority of their culture over that of the unrefined Americans. On the other hand, not all Americans avoided anti-German bias. The "Dutch," as they often were mistakenly called, were loud and spoke English poorly, if at all, and if they didn't like it here, well, they could go back where they came from. These mutual misgivings would only grow in the early to mid-1850s. In the meantime, regardless of social or political persuasion, new arrivals from Germany or longer-term residents shared one common denominator: a love of beer and the opportunity to enjoy it on their single day off.

How Lager Struck a Blow for Liberty

German Americans experienced their own sociopolitical divisions. The refugees of 1848, "the Greens," quickly unsettled an already uneasy balance that existed between their older, conservative predecessors, "the Grays," and native-born Americans. Militants who had laid their lives and fortunes on the line to change the future of their homeland could hardly be expected to shed their passions so they could blend in with those who had been acclimated if not assimilated. They rocked the boat. Many took up the antislavery cause with the same zeal they'd applied to the revolution. Leading Forty-Eighters also embraced the renewed struggle for women's rights, born at the first women's rights convention in the United States, in Seneca Falls, New York, coincidentally in 1848 (July 19 and 20). The small town in the western part of the state was the home of Elizabeth Cady Stanton, who organized the gathering with Lucretia Mott and a handful of others active in the abolition and temperance movements. The three hundred or so attendees included about forty men. Their goal was to call attention to the unfair political and economic treatment of women. Nearly all came from the immediate area. Stanton wrote the document that would be debated and signed by the attendees. She based the Declaration of Sentiments on the Declaration of Independence (authors' emphasis): "We hold these truths to be self-evident: that all men *and women* are created equal."

This historic gathering symbolized the convergence of three causes that would both dominate and divide American thought for years to come: emancipation, temperance and the rights of women, most notably the right to vote. The Emancipation Proclamation followed by Union victory in the Civil War would eradicate slavery, leaving temperance and suffrage to be addressed. So intertwined were these two movements that some historians suggest it was no coincidence that the constitutional amendments establishing prohibition and women's right to vote were adopted one year apart, in 1919 and 1920, respectively.

While the antislavery cause drew support across a wide spectrum—gender, class, religion and national origin—the other two causes, in their antebellum forms, sprang from more limited origins. The temperance movement was rooted in American Protestant churches. The struggle for women's rights was led primarily by upper- and upper-middle-class white women. Illinois offered a case in point: Mrs. Susan Hoxie Richardson, an eastern transplant and cousin of Susan B. Anthony, organized Illinois' first women's suffrage society in LaSalle County.

Many Americans enthusiastically supported all three, believing them to be inextricably linked. Emancipation advocates, for instance, saw drink as

another form of slavery. Women's rights supporters sought to protect families from the poverty and violence caused by the drunkenness of a husband or father. A petition filed by a Chicago wife and mother in the 1850s is illustrative. Mrs. John Caffrey (whose first name has been lost in history) pleaded with the city's common (later city) council to free her husband, who had been jailed for drunkenness. Claiming that he had been "induced by others to take some liquor," Mrs. Caffrey asked the council "not to turn a deaf ear to the prayer of a poor wife and innocent little ones, but that they will at once unbar the gate, and lead the husband forth to life and light, and that he will sin no more." He had erred, she admitted, but she and the children were the victims because he was the breadwinner. Caffrey was released.

Some significant divisions developed in the progressive ranks. Not all German Forty-Eighters were enthusiastic about female emancipation. Liberal in other beliefs, some clung to the traditional image of women's domestic subservience. Also, not all female temperance advocates embraced suffrage, seeing it as a distraction and possible source of alienation among the men they sought to enlist. Soon after the Seneca Convention, Stanton and Anthony, one of the most prominent civil rights leaders of the nineteenth century, became close friends. Not only an outspoken crusader for women's suffrage, Anthony was a leading abolitionist and a pioneering figure in the temperance movement. Together, Stanton and Anthony formed the New York State Women's Temperance Society in 1852. They had no problem working simultaneously for suffrage and other feminist goals. Anthony's decision to launch a women's temperance organization developed from a snub. A Quaker and already a recognized temperance leader, she attempted to speak at a New York state temperance conference but was informed that the ladies had been invited to listen and learn, not open their mouths.

A temperance meeting was about the last place one would have expected to find U.S. Senator Stephen Arnold Douglas of Illinois. A prolific imbiber, Douglas was a Protestant whose second wife, Adele Cutts, was a Catholic from Maryland and a grandniece of Dolley Madison. Early on, he warmly welcomed Irish Catholic immigrants into the Democratic Party and established a bond that would last not only his lifetime but for generations to come. Douglas sought compromise on the slavery issue as a way to preserve the Union and avoid civil war, but when Confederate guns fired on Fort Sumter, he rallied to the Union cause.

Douglas's polar opposite in the odd mixture of antebellum Chicago personalities was Mayor Levi Day Boone, stridently anti-immigrant, anti-Catholic and pro-temperance. Boone not only believed in slavery, but he

How Lager Struck a Blow for Liberty

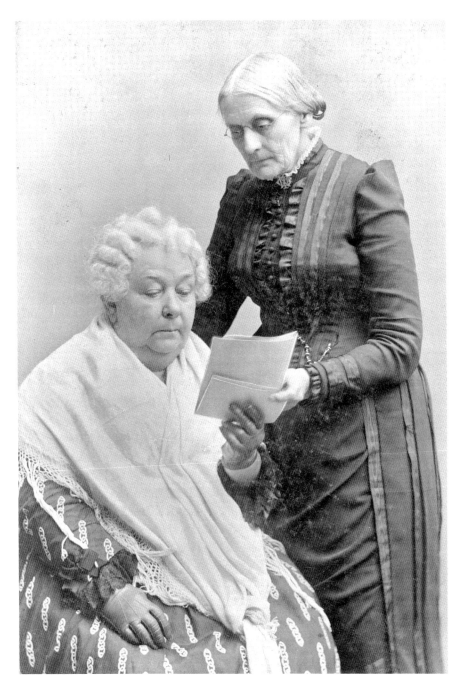

Elizabeth Cady Stanton (left) and Susan B. Anthony campaigned on three fronts—for temperance, women's suffrage and emancipation of the slaves. *Courtesy of the Library of Congress.*

The Great Chicago Beer Riot

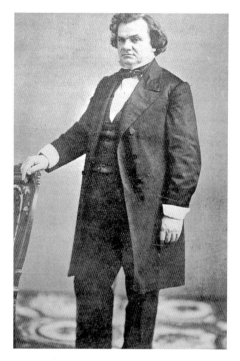

also took to the church pulpit to defend it. Yet when war came, he declared himself staunchly behind the Union. Nonetheless, in a strange twist of fate, he found himself arrested and incarcerated for allegedly aiding the attempted escape of a Confederate prisoner of war.

Another fascinating personality who left his mark on pre–Civil War Chicago was the abolitionist Frederick Douglass, who had escaped slavery and become a U.S. citizen. He was also an outspoken proponent of temperance and women's suffrage but was more equivocal about immigration. Douglass saw European arrivals taking manual labor jobs that he envisioned for freed slaves. "[E]very hour sees the black man elbowed out of employment by some newly arrived emigrant, whose hunger and whose color are thought to give him a better title to the place." Yet Douglass and others in the black abolitionist cause did

Top: U.S. Senator Stephen A. Douglas, a prolific imbiber, wooed immigrant voters with his anti-prohibitionist policies. *Courtesy of the Chicago Public Library.*

Left: Levi Day Boone, medical doctor, one-term mayor and grand-nephew of legendary frontiersman Daniel Boone. His decision to ban the sale of alcohol on Sunday sparked the Lager Beer Riot. *Courtesy of Chicago Public Library, Special Collections and Preservation Division, CCW 1110.*

not oppose immigration. They viewed it as beneficial to nation building as long as blacks got a seat at the table, too. Douglass and his colleagues became impressed and influenced by German American liberals who befriended them, according to scholar Hartmut Keil, who expounded on this association before a German American studies audience in 1999. Keil quoted Douglass as saying, "Many noble and high-minded men, most of whom, swept over by the tide of the Revolution of 1848, have become our active allies against oppression and prejudice."

The ubiquitous Douglass, one of forty men and thought to be the only African American who attended the Seneca Falls convention, spoke in favor of Stanton's Declaration of Sentiments, demanding women's suffrage. Both Anthony and Stanton believed that women and black men should be granted voting rights simultaneously. Douglass maintained that prejudice and violence against black men made their case more pressing. But what about black women, asked Sojourner Truth, former slave and civil rights crusader; no one was saying a word about them. "[I]f colored men get their rights and colored women not theirs, the colored men will be masters over the woman, and it will be just as bad as before." The Douglass viewpoint prevailed. Women, black and white, would have to wait more than half a century longer than black men to win enfranchisement.

In October 1845, Douglass arrived in Cork, Ireland, wearing his temperance hat and telling a highly receptive audience that "if we could but make the world sober, we would have no slavery. Mankind has been drunk." Douglass maintained that drink was retarding the progress of the antislavery movement, furnishing arguments to opponents who "have

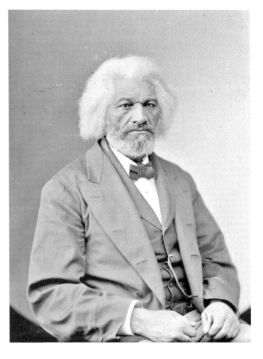

Former slave and abolitionist Frederick Douglass crusaded against alcohol almost as fervently as he did against slavery. *Courtesy of the Library of Congress.*

pointed to the drunkards among the free colored population and asked us the question, tauntingly, 'What better would you be if you were in their situation?'" Warming to his theme, he said, "All great reforms go together. Whatever tends to exalt humanity in one portion of the world, tends to exalt it in another."

There is no question that the ex-slave from America formed a fraternal bond with his Irish hosts, at least the nondrinking segment of the population. A deeply appreciative Douglass declared that the warmest reception he'd ever received, at home or abroad, occurred at a temperance meeting in Dublin. He surely was saddened by the ordeal that befell the Irish over the next three years. Just a month before he spoke in Cork, the first vestige of the potato blight had appeared.

By the time the devastating famine that followed had reached its third year, the last thing the suffering millions of Ireland needed was a political rebellion. They got one anyway when the democratic fever sweeping Europe in 1848 descended on the island nation. A radical group called Young Ireland, eager to revive the spirit if not the outcome of the 1798 rising, decided that the time was right to liberate the country from British rule. Its struggle lasted only until July. "[T]he truth was that the general population was so brow-beaten by the extremes of starvation, death, illness and emigration that there was no popular support for the rebellion…In the immediate famine and post-famine years, there was a deep apathy across Ireland for political activity," observed Mike Cronin in *A History of Ireland*.

Many Young Ireland leaders fled to America. One arrived belatedly after escaping from a Tasmanian penal colony. He and his comrades brought their political activism with them, raising money and drumming up support for a future rising. "For these activists, the famine provided a tool to politicize the masses. Their influence on Irish and Irish-American thinking long outlived the crisis that precipitated their revolt," according to Kerby A. Miller in *The Great Famine and the Irish Diaspora in America*. "Their bitter interpretations of famine, evictions and emigration…provided much of the nationalist catechism for later generations on both sides of the ocean." Irish who never experienced the Great Famine learned from childhood how their countrymen were "butchered, starved and ground by the iron heel of the robber Saxon," in the words of a screed written by John Mitchel, the rebel who escaped from Tasmania.

The potato blight that caused the famine was triggered by a fungus first identified in Wexford in September 1845. At the time, roughly one-third of the country's population was reliant on potato crops raised on small plots.

How Lager Struck a Blow for Liberty

Initially, the blight remained localized, and the British government stepped in to provide assistance. Famine didn't begin until a year later with the second failure of the potato crop. The populace found itself squeezed on one side by a much more widespread crop failure and on the other by a new, far less sympathetic administration in London. A program that was providing free soup to 3 million people was terminated after only a few months. Throughout the famine, callous absentee landlords continued to export wheat and cattle to England while they evicted starving tenants for nonpayment of rent. Historian Miller cited the account of a visitor to the north midlands who "saw sights that will never wholly leave the eyes that beheld them, cowering wretches almost naked in the savage weather, prowling in turnip fields and endeavoring to grub roots…little children…their limbs fleshless…their faces bloated yet wrinkled and of a pale greenish hue."

Scenes such as this were multiplied by the tens of thousands. Between 1845 and 1851, approximately 1.1 to 1.5 million died of starvation or related diseases, 500,000 were evicted, 3 million landed on welfare and another 1 million found themselves in poorhouses bursting at the seams. The population of Ireland stood at 8.5 million in 1845. Six years later, it had been reduced by more than 2 million, half by death and half by emigration. Almost 40,000 of the emigrants never made it to a distant shore, unless it was to a contagious diseases quarantine. They died aboard so-called coffin ships, where they succumbed to illness or went down on vessels so unseaworthy that they couldn't survive the Atlantic crossing.

Those who fled the famine differed from their predecessors in several regards. For one, families composed a large proportion of famine emigrants compared with earlier waves of young singles in search of opportunity in a new land. People escaping the Great Hunger generally were much poorer, less skilled and in need of charity to finance their departures. An estimated 90 percent of those who left during the famine were laborers. These were the Catholic poor, about one-third of them Irish speakers from the western counties—in other words, immigrants destined for the lowest rung of the American socioeconomic ladder. There they were handed the lowest-paid, least skilled, most dangerous and least secure employment—when they could find jobs at all. If they sought to better their station, they often encountered signs bearing the acronym NINA—No Irish Need Apply. It should have come as no surprise that this class, with few exceptions, found itself living in densely populated and segregated communities, in substandard housing with poor sanitation, disproportionately dependent on welfare and candidates for prison. Their transition from rural Ireland to urban America,

The Great Chicago Beer Riot

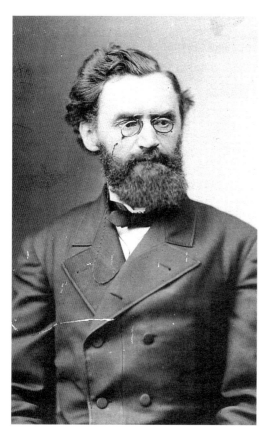

One of the nineteenth century's most eminent German Americans, journalist, U.S. senator and presidential cabinet member Carl Schurz wrote an unflattering yet whimsical account of his initial reception by Chicagoans. *Courtesy of the Chicago Public Library.*

Lawrence J. McCaffrey wrote in *The Irish in Chicago*, made them "the paradigm of the American ethnic experience," their turbulent pilgrimage a preview of "the adventures of other non-Anglo Protestants."

The Germans and Irish who arrived in Chicago during the late 1840s and early 1850s found a city undergoing a transformation that might have made them forget, at least for a while, the tragic circumstances that drove them there. Railroads were expanding, factories rising, the population booming, lake and river traffic flourishing and a new canal opening. The expansion was almost enough to make the newcomers ignore signs that not everyone was glad to see them. Just like back home, the land of liberty contained people who would dislike them for social, economic, political or religious reasons—people who would withhold the welcome mat from those who spoke, dressed or behaved differently or worshiped in what was deemed an unacceptable way.

Carl Schurz, a student leader of the 1848 revolution and one of the great German Americans of the nineteenth century, wrote a whimsical, allegorical letter to his wife back home during an early visit to Chicago. He said that as he roamed the streets in the early morning hours in an unsuccessful search for lodging, he discovered that "Chicago has wooden sidewalks under which live millions of rats. These rats regard the streets at night as their domain…Rats of all sizes and colors, old and young, white and gray, played charmingly about my feet." Schurz wrote of sitting down on a curbstone

How Lager Struck a Blow for Liberty

and being addressed by a large rat "who seemed the oldest and wisest of all…(American rats naturally spoke only English)."

"'What do you want here, stranger?' said the speaker. 'Why didn't you stay with your lovely wife and child? Why did you come into this distant country, in the pursuit of wealth and earthly things? Fool that you are!'"

Schurz said that he replied, "Mr. Speaker and fellow rats! I am exceedingly sorry to have trespassed upon your mighty rights and privileges by the unfortunate fact of my presence. But, gentlemen, you may be sure that I never should have taken such an indecent as well as dangerous course, if not beings of my own race, men with hearts of stone, had kicked me away from their doors and turned me into the deserted streets."

He threw himself into the arms of the rats, he related, "trusting to the world-renowned hospitality of the noble rats of Chicago." The rats responded by naming a "committee of arrangements" that offered an apology for its "harsh and discourteous tone." The speaker invited Schurz to dine with him and his wife and spend the night at their home.

"Thereupon the speaker pointed out to me a knothole in one of the planks of the sidewalk only big enough to enable me to stick two fingers in it. I was about to fall into a state of high indignation when I was awakened out of my slumber by a man who told me that I had been on the point of falling off the curb, etc. I told him my story, and he guided me to a hotel in which I found a room."

Schurz went on to describe a night of encounters with bedbugs but concluded his letter home with the unexpected observation that "[t]his young city is one of the most marvelous phenomena of America, or indeed the world." Is he slyly mocking Chicago's attitude toward foreigners but not so slyly the condition of its streets, walkways and lodging houses? Probably, but his final sentence remains unequivocal. Carl Schurz adapted to the city and nation well enough to become a leading journalist, Civil War general, the first German-born American elected to the U.S. Senate and U.S. secretary of the interior.

Although the cousin Schurz came looking for had left town on a business trip, he found plenty of other countrymen who were on their way to surpassing the Irish as Chicago's most numerous foreign-born population. The first German settlers were believed to have put down roots in about 1825 at Dunkley's Grove, now suburban Addison, according to *A History of Chicago* by Bessie Louise Pierce. Chicago probably saw its first Germans about five years later. Unfortunately, demographic and other records were destroyed along with city hall and additional repositories by the Great Fire of 1871.

The Great Chicago Beer Riot

The city elected its first German alderman, Charles Sauter, in 1839. Kaspar Lauer, a German whose family emigrated from France, is sometimes identified as the first policeman killed in the line of duty. He was the first to carry the title of patrolman, but the first law officer of any type to die that way was Constable James Quinn, an Irish immigrant, who was killed in December 1853, nine months before Lauer. Also in 1853, Chicago's first Sunday newspaper appeared. It was the German-language publication *Der Westen*. Its editor, Georg Schneider, was another Forty-Eighter. He had fled to the United States in 1849 after being condemned to death for his part in the revolution. In 1851, he bought the influential weekly paper *Illinois Staatszeitung* and turned it into a daily. Like Schurz, Schneider was one of at least four prominent German journalists who followed similar paths for similar reasons. Lorenz Brentano, who later owned the *Staatszeitung*, was sentenced to death for leading a revolutionary political party in Baden. Wilhelm Rapp, who penned editorials for the newspaper, found himself imprisoned in a fortress in 1850 and 1851 and was later tried for treason.

Not surprisingly, the city's first brewers were German. Wilhelm Hass and Conrad Sulzer went into business in 1836, the year before Chicago became incorporated as a city. (Elements of this book were researched and written at the Conrad Sulzer Regional Library.) By the 1850s, the city's Germans made up significant percentages of the key trades, with cigar makers, cabinetmakers and bakers leading the way at 78, 74 and 68 percent, respectively. The ranks of shoemakers, butchers and tailors also contained a majority of Germans.

The influence of the Forty-Eighters far outweighed their comparatively small percentage of the German immigrant ranks. "Their severest critics admit that the refugees infused new life into the German-American group," observed Carl Wittke, "and for the first time gave them aggressive political leadership." They formed the Club of Old '48 to preserve the memory of the turbulent days of the uprising. The organization remained active well into the twentieth century, gathering in rathskellers whose walls displayed verses in Gothic lettering and portraits of the heroes of Forty-Eight. They sang old songs, rehashed past causes, read the German newspapers and drank beer—determined to preserve their language and culture.

Overall, typical German immigrants didn't ask for more than people anywhere—an opportunity to earn an honest living, raise a family and enjoy life on their own terms. What frequently set them apart from native-born Americans was how they enjoyed life on their own terms. They particularly cherished a unique style of Sunday outings at picnic groves. These were

How Lager Struck a Blow for Liberty

German American families cherished Sunday afternoons in the picnic grove, highlighted by band music, dancing and, of course, a copious supply of beer. *Courtesy of Conrad Sulzer Regional Library, Chicago Public Library, North Side Neighborhood History Collection, RLVCC 4.12.*

family affairs but by no means quiet "Sunday in the park" events. They were highlighted by loud music, dancing and, of course, the copious consumption of beer—all features certain to offend starchy Puritan sensibilities. A trip to the grove began with a parade led by a blaring marching band that sometimes followed a route past churches crowded with Yankee worshipers. "Blaring bands, Sunday picnics, dances, parades and noisy German beer halls deeply offended many Americans and challenged the long-established custom of many a community," Wittke noted.

Much of the native antagonism toward the German way of life can be written off to basic xenophobia. Some of the Forty-Eighters, however, seemed to take particular delight in what could be called in later years an "in your face" attitude. Many Forty-Eighters, Wittke maintained, "took keen delight in flaunting their Continental tastes in the face of Americans whom they regarded as little better than barbarians—men without art, music, culture or refinement, who were suppressed and crushed by the bigotry of Puritanism." German Catholics and Lutherans alike were appalled by the behavior of the radical newcomers, a reaction that mattered not at all to the upstarts, who were equally vocal in expressing their contempt for all religion.

The Great Chicago Beer Riot

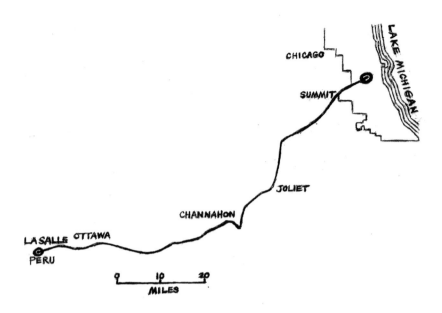

The Illinois and Michigan Canal, completed in 1848, opened a new trade route into Chicago and created jobs for numerous Irish Americans, who helped to build it. *Courtesy of Alex A. Burkholder.*

Antipathy toward newcomers by those who "got here first" is a universal condition as old as the race. As early as 1840, a Chicago newspaper published a petition signed by 250 Illinois residents asking Congress to deny the right to vote to any foreigners not already enfranchised. A Puritan oligarchy, stern, cold and exacting, ran Chicago in its early years and held to its own variation of the "divine right of kings," the belief that they had been endowed by their New York and New England forbearers with the political, social and moral leadership of the United States. Apparently, the thought never occurred to them that the German Forty-Eighters and, to a lesser degree, the Young Ireland rebels shared a lot in common with the American colonists of 1776.

The working poor who came over from Ireland wouldn't have had time to discourse on Hegel, Fichte or Kant, even if they knew who they were. Many of the earliest arrivals, those who preceded the famine-induced migration, came to dig the Illinois and Michigan Canal after being recruited by contractors. Some had worked previously building the Erie Canal, which opened in 1825. Thousands of Irish immigrants were employed on the I&M project and lived in transient work camps along its ninety-six-mile route. In 1836, at the start of the undertaking, the State of Illinois created

a subdivision at what was to become the northeastern terminus of the canal to accommodate the influx of laborers. Initially given the apt name Hardscrabble, the area later became known as Bridgeport, future spawning ground of Chicago mayors, including two named Daley. Bridgeport has also produced generations of city patronage employees.

After its inception, the community filled quickly with Irish laborers, who put down roots following completion of the waterway in 1848. Some of the former Irish canal workers gravitated to the North Side, where they were outnumbered by the Germans, who also owned a greater percentage of property, there and citywide. In 1850, according to Robin L. Einhorn in *Property Rules: Political Economy in Chicago, 1833–1872,* 29 percent of Chicago's immigrant property owners were German and 17 percent Irish. These figures can tend to exaggerate the extent of ownership by immigrants, as data cited by Einhorn reveals that "the wealthiest one percent of Chicago's adult males in 1849 and 1850 owned fifty-two percent of the city's wealth," a greater disparity than that of major eastern cities. Less than one-fifth of all adult males in 1850 Chicago were property owners. (Women's right to own property in Illinois was not affirmed until an 1867 decision by the state Supreme Court.)

Property ownership must have seemed a distant if not totally unachievable dream for immigrants whose everyday lives were a struggle. The nation's boom-or-bust cycles in the nineteenth century, highlighted by depressions in the 1830s, 1840s and 1850s, meant that an unforeseen crisis could be lurking just around the bend for a family barely getting by. Men with little more than a strong back to offer in return for a paycheck were not in the best bargaining position. Many dreams of owning a little cottage in Bridgeport or Kilgubbin on the North Side had to be dreams deferred. Individuals and families found themselves confined to "ugly, dirty and dreary neighborhoods [that] spawned crime, violence, and mental and physical disorders," observes McCaffrey. Prominent among the disorders was a disease dubbed in later years "the Irish sickle cell"—alcoholism. The Irish had their whiskey and the Germans their beer. Some in each group fancied both.

Author McCaffrey pointed out that the Irish were unique among European immigrant groups for two reasons: women and men arrived in about equal numbers, and a vast majority of both were single. (The period of the famine years proved an exception, as families predominated.) "Irish women," he noted, "made a better adjustment to the United States than did men and were more successful economically than Irish men or other women. After leaving a strict paternalistic society, they aggressively pursued

economic independence." Once married, however, Irish women were more likely to leave the workforce and concentrate on raising families that often grew large.

Like their German counterparts, the Irish who arrived in Chicago in the 1840s and 1850s encountered resistance from some of their American neighbors. Yankees who disdained the Germans' perceived haughtiness, their manner of speech, raucous beer halls, blaring bands and other irritants had even less tolerance for the filth, crime, drunkenness and other ills that afflicted the poverty culture of Irish American ghettos. Transcending all else was the one "ism" that the nativists simply could not abide: Catholicism. "Rooted in the English historical tradition," McCaffrey maintained, "anti-Catholicism was the intrinsic ingredient in American nativism." German Catholics, much smaller in number, seemed to escape the vitriol. Any group that owed its allegiance to a foreign pope, the nativists believed, could never become true Americans. In 1855, the *Chicago Tribune* editorialized, "Who does not know that the most depraved, debased, worthless and irredeemable drunkards and sots which curse the community are Irish Catholics? Who does not know that five-eighths of the cases brought up every day before the Mayor for drunkenness and consequent crime are Irish Catholics?"

Welcome to Chicago, ye sons and daughters of Erin! (And you krautheads aren't much better!)

WHAT ELSE THEY FOUND

Chicago's birth, followed by its spectacular growth, sprang from the opportune confluence of Lake Michigan and the Chicago River. The opening of the Erie Canal in 1825 provided a new route to easterners looking to migrate west. The canal linked the Hudson River with the Great Lakes and opened new avenues of water to Buffalo, Cleveland and Detroit, along with Chicago. Steam navigation on the Great Lakes began in 1833, the year Chicago became incorporated as a town.

Over the next three years, the number of vessels annually entering Chicago's harbor multiplied a hundredfold—from four to four hundred. In another generation, the city would witness that many arrivals on two good days. "Lumber from northern Wisconsin and Michigan, iron from the northern Great Lakes area, men and goods from the East, all moved across the water to the crowded wharves of the river, while other vessels carried grain of the new country to mills in New York and New England. Tonnage entering the harbor jumped from 440,000 in 1844 to over three million in 1869," as Harold M. Mayer and Richard C. Wade observed in *Chicago: Growth of a Metropolis*.

Steamers from the East not only increased in number and speed but in passenger comfort as well. Mayer and Wade cite as an example the *Empire*, "the pride of the Great Lakes," which ran between Buffalo and Chicago, the route followed by most northern European immigrants heading west. But few, if any, Irish or Germans fleeing for their lives arrived aboard the *Empire* or any vessel like it. "She had luxurious staterooms, a spacious dining room,

a paneled bar and strolling musicians." The contrast between the *Empire* and the famine ships couldn't have been starker. Maybe a lucky transatlantic passenger had been able to save a fiddle or squeeze box. And the reference to men arriving from the East wasn't a chauvinistic misnomer. Most of the arrivals were, in fact, male. The more direct of Chicago's multitude of bachelors were said to frequent the docks in the hope of meeting one of the comparatively few single women disembarking.

From the southwest, the I&M Canal, first envisioned by explorers Marquette and Joliet a century and a half earlier, began delivering prosperity to the region immediately after its opening in 1848. The canal linked Chicago to the Des Plaines and Illinois Rivers and, ultimately, the Mississippi. Along its narrow route sprang up more than a dozen permanent communities, including Lemont, Romeoville, Lockport and Joliet. Shallow as well as narrow and handicapped by a complicated limestone lock system, the canal couldn't accommodate steamboats and made slow going for barges. Despite the obstacles, "the canal was a major factor in the extraordinary growth of Chicago in the next two decades," according to Mayer and Wade, and "it drew more and more of the surrounding country into the city's commercial orbit." In came salt, wheat, corn, pork, lumber and coal, much of it destined for consumers to the north and east of Chicago.

Tragically, the Illinois and Michigan Canal also delivered death on a grand scale. On April 29, 1849, the boat *John Drew* arrived from New Orleans carrying a full complement of immigrants whose nationality isn't recorded in surviving records. A local man named John Pendelton contracted cholera from someone aboard the *John Drew* and died a few hours after the boat docked. A number of passengers also died soon after their arrival. Chicago wasn't caught by surprise, however; cholera had been raging up and down the Mississippi after spreading across Europe and the eastern United States. The disease was introduced and spread by immigrants from Europe, asserted A.T. Andreas in his 1884 history of the city. Here was one more reason for some native-born Americans to shun if not detest foreign arrivals.

Chicago had been through a cholera epidemic fifteen years earlier and took steps to avoid a reemergence. Unfortunately, the measures yielded few if any results because the source of the disease, water-borne bacteria, wouldn't be identified until years later. Not illogically, the common council ordered a massive cleanup to eradicate filth and appointed forty-five assistant health commissioners to supervise the assault. Homeowners were ordered to remove all debris from their lots. There was no shortage of theories or quack cures. Poor nutrition increased susceptibility, some believed. A newspaper article

warned against the consumption of whiskey, "a known cause." A doctor, no less, reported that a woman who died of cholera had contracted the disease by eating hot biscuits. A newspaper ad promoted the sale of Kirby's Cholera Drops, which promised to instantaneously check the most violent attacks and bring "universal satisfaction." The ad contained testimonials from users certifying that the drops had worked as promised. No one at the time linked the disease to the way the city disposed of its sewage into the Chicago River, which flowed into Lake Michigan, the primary source of drinking water.

Prior to 1834, vendors drew water from the lake and sold it from horse-drawn carts that went from house to house. That year, the city sank a municipal well on the north bank of the river, and the well became the principal source until 1842. At that time, a group of leading citizens obtained a state charter, formed the Chicago Hydraulic Company and built a two-story pumping station on the lake at Lake Street. The plant delivered water to the city's inhabitants through a network of underground wooden pipes. The pipes held up remarkably well for a number of years, but the threat of cholera would remain until the end of the century, when a bold, innovative engineering project reversed the flow of the river and cleansed the lake. But at midcentury, the epidemic raged on.

By the end of August 1849, cholera had infected some 1,000 victims, 314 of whom died. It represented a gruesome though mercifully speedy way to go, marked by violent diarrhea, vomiting, cramps and fever followed by death, usually hours after the onset of an attack. Historian Andreas mentioned an account written by an "old settler" who "had a narrow escape from death himself." Learning of the passing of a friend, a Baptist deacon named Captain Jackson, the writer tells of calling at the Jackson home: "I found William Jones alone with the corpse, the family being in an upper room, from whence I could hear their united wailings. The face was a shade darker than usual, and around the mouth were the dark purple spots, which I soon learned to be the unmistakable deathmark of that dreaded and terrible disease—the Asiatic cholera. Mr. Jackson had been attacked the previous afternoon, while engaged in his usual employment of driving piles and building docks along the river; he hastened home and died within a few hours."

August 1 marked the worst single day of the 1849 epidemic—30 dead. Hardest hit was a section of the North Side mainly populated by Norwegians, including many recent arrivals. Some inhabitants fled the city in panic, aldermen among them. A newspaper editorial demanded that their seats be declared vacant. "In times like these, every man should be at his post…There is now a panic in our city far worse than the cholera

itself. Many are leaving the city and those remaining seem afraid to go near those in distress."

Someone who stepped forward, to the gratitude of a frightened public, was Dr. Levi Day Boone, the city's chief health officer. Boone was the seventh son of a nephew of legendary Kentucky frontiersman Daniel Boone. The father of eleven himself, he was a founder and first secretary of the Cook County Medical Board and, later, the first president of the Chicago Medical Society. Boone oversaw the placement of a temporary hospital for the treatment of cholera cases on Eighteenth Street, near the river. A second facility, on Erie Street between Wells Street and the river, became the subject of an "exposé" by the newspaper *Chicago Democrat*, which was owned by Congressman John Wentworth. The paper said its "informant" discovered "the bodies of a man and his son…in a coffin on a wretched pallet within sight [of] the wife and mother. There was but one attendant—a man." A livid Dr. Boone rebutted the account, describing an adequately sized building where patients were treated by a county physician and two attendants, one "as good a nurse as can be found in the United States."

Boone had to confront both the epidemic and those who objected to the placement of treatment facilities in well-populated areas. "This is the second attempt that has been made by the city authorities to provide a place for homeless and friendless persons who might be attacked with cholera in the city and also the second time that inhuman persons have

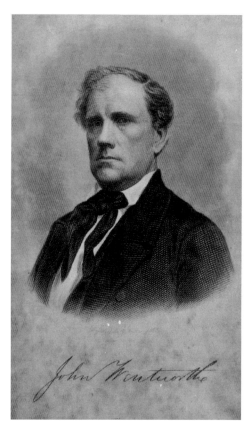

"Long John" Wentworth, congressman, mayor, newspaper editor and investor, whose Falstaffian lifestyle did not include beer. "It's nasty stuff, makes you soggy and fat and lazy." *Courtesy of Chicago Public Library, Special Collections and Preservation Division, CCW 1.266.*

threatened to demolish it." Boone himself ordered the hospital closed in September as the epidemic began to wane but it had to be reopened the following month for several more weeks. In late October, a permanent General Hospital of the Lake at Eighteenth Street and the lakefront was authorized by the Illinois legislature. William K. Beatty, author of a *Chicago History* magazine article, described the facility it supplanted as a "pest house…where cholera patients entered one door, smallpox patients the other, and few left alive."

By the time the epidemic ran its course for the year, coinciding with the opening of the new hospital, the city had lost about 3 percent of its population—678 lives. Immigrants proved especially susceptible. For some inexplicable reason, the cholera seemed to hit Norwegians the hardest. In just a single three-block stretch of the North Side, that group accounted for a substantial majority of the staggering 332 cases recorded.

Cholera returned each year through 1855, claiming 420 in 1850, 216 in 1851, 630 in 1852 and 113 in 1853. The annual visitation began to taper off in 1854 with a smattering of cases. Historian Andreas noted that the board of health and the newspapers tried to deny the resumption "under the mistaken idea that to deny the existence of evil goes toward killing it." Once again, Norwegian immigrants formed the bulk of the outbreak. A train carrying Norwegians bound for Wisconsin arrived in Chicago in late June 1854—6 on board already had died of the disease, and another succumbed shortly after being removed; 20 more were hospitalized, forcing the first official acknowledgement of cholera's return. In the immediate aftermath, the disease seemed to be making up for lost time—242 died in the first week of July alone. At one point, an average of 60 per day were perishing. The streets of the city became jammed with hearses. Author Beatty cited a reminiscence by the son of a German immigrant:

> *Father drove the hearse and helped lay out the bodies. He used to haul fourteen and fifteen bodies a day and that not during the worse* [sic] *time… He used to work day and night. People died so fast they could not dig holes enough. Deaths were so numerous that the coffins & contents were filled up waiting their turn for their holes. Even mother remembers how they were filled up near the old burying ground between Menomonee* [Street] *and North Avenue, now Lincoln Park.*

The city clerk's office didn't begin tabulating causes of death until 1851. Between then and 1856, when cholera virtually disappeared for a number

of years, total fatalities stood at 2,430. Adding in the unofficial counts for 1849 and 1850, it appears that 3,528 lost their lives to cholera. A more precise figure will never be known. Recordkeeping was haphazard. Patients sometimes were misdiagnosed or their cause of death listed erroneously.

Levi Boone earned the admiration of Chicagoans for his performance as city physician between 1848 and 1851 and afterward as a doctor in private practice. At the time of his death in 1882, the *Chicago Tribune* declared that "his administration of the hospitals, crowded with cholera and smallpox patients, [exhibited] a percentage of cures not exceeded in the history of the city and probably not of any other." He went on to serve three one-year terms as alderman of the Fourth Ward just south of the river, yet despite his accomplishments and civic status, Boone remained a composite of contradictions. The man behind the gold-rimmed glasses and flowing white beard (no mustache) was a skilled and dedicated physician, a pillar of the Baptist Church, a shrewd politician and a staunch supporter of the Union at the outbreak of the Civil War. Simultaneously, he was a vocal proponent of slavery who delivered lectures that cited biblical support for the practice. (One example chosen by the authors: "As for your male and female slaves whom you may have: you may buy male and female slaves from the nations that are around you." Leviticus 25:44–46. Some Bible passages condemn slavery.)

Boone's lectures to prove that slavery was in accordance with the scriptures contributed to a fissure in the ranks of Chicago's First Baptist Church, whose membership was almost equally divided between proslavery and antislavery parishioners. Abolitionists in the congregation were as upset by Boone's preachments as their counterparts were with their pastor's participation in ecumenical prayer meetings on behalf of slaves. After four years of friction, thirty-four members of the antislavery faction left First Baptist and Boone in 1843, according to the Andreas history, and formed the Tabernacle Baptist Church. Their parting resolution diplomatically mentioned nothing about the slavery issue, attributing the decision to organize a second church to "the state of this community, and the growing importance of this location and the rapid increase in population." Their departure didn't end Boone's efforts to stamp his convictions on the Baptist Church. Historian Einhorn pointed out that in 1853, the doctor bought an antislavery Baptist publication called *Watchman of the Prairies* for the sole purpose of shutting it down.

It wasn't unusual for someone who grew up in Kentucky in the early 1800s, as Boone did, to be proslavery. A large number of those who settled southern Illinois at that time came from Kentucky, Tennessee and Virginia. Boone migrated to Downstate Edwardsville before moving to Chicago in the

How Lager Struck a Blow for Liberty

mid-1830s. The doctor also held strong opinions about European immigrants, particularly the Irish; he detested them and the Catholic Church with equal fervor. He was a temperance advocate who reportedly drank grog in private. Chicagoans would become more familiar with the outspoken beliefs of Dr. Levi Boone in the years immediately ahead.

Around the time Boone was arriving in Chicago, William Butler Ogden was about to become the first mayor of the about-to-be-incorporated city. Ogden arrived in the early settlement as an ambitious young man in search of his fortune "while as yet the Indian paddled his canoe on Lake Michigan, or chased the deer over the prairies, and the mighty howling of wolves disturbed the repose of Chicago's first settlers," Andreas recorded. Ogden became an

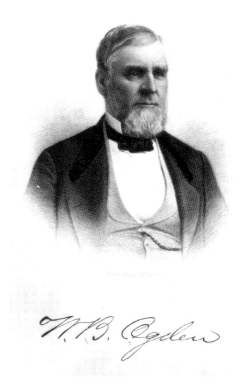

The city's first mayor, William Butler Ogden, played a pivotal role in so many early ventures that a visiting French historian called him the man who built and owned Chicago. *Courtesy of Chicago Public Library, Special Collections and Preservation Division, CCW 1.251.*

important influence in the construction of the I&M Canal, built the first railroad that entered the city, constructed thousands of miles of rail tracks, operated a Lake Michigan freight and passenger line, acquired vast real estate holdings, financed the city's first bank, got into the brewery business and touched virtually every other facet of early Chicago. He was the man who built and owned Chicago, in the succinct view of a contemporary French historian. Like Boone, he also had little use for the Irish newcomers. "Poor and vicious foreigners," he called them, people who lived in squalid "shanties and rookeries." Boone must have appreciated the presence of a kindred spirit.

As for Ogden's multitude of business accomplishments, none ranks higher than his early initiatives that would make the city the railroad hub of the

nation. Ogden's entrepreneurial mind first dreamed of a railroad running from Chicago in 1836. His plan was to link the town to the prosperous lead mining community of Galena, Illinois, about 150 miles to the west. This was bold stuff for the times. The world's first public railway had made its debut only eleven years earlier. Ogden and his partners laid out the route on paper, but it would take another dozen years before any track got put down. Economic depression struck the country in 1837. Not only did investment capital dry up, but a number of potential investors also went bankrupt.

In 1847, the ever-imaginative Ogden, with the help of Congressman Wentworth, tried a new tack. To interest eastern investors, the now-former mayor took the lead in organizing a River and Harbor Convention, described by one attendee as "the largest deliberative body ever assembled" and by historian Donald L. Miller in *City of the Century* as "the first national gathering in what would become America's convention city." Depending on who was counting, three thousand, ten thousand or twenty thousand attendees converged on a city of sixteen thousand. Delegates and onlookers gathered under an enormous tent in the center of the city. Their ranks included prominent national figures such as Horace Greeley, publisher of the *New York Tribune*, and not-so-prominent figures such as an obscure Downstate congressman named Abraham Lincoln.

The ostensible purpose of the conclave was to push for federal aid to transportation projects in the western United States. Ogden's and Wentworth's additional motive was to attract eastern investment in Chicago and, more specifically, in the Chicago–Galena railroad. The city's continued growth, civic and business leaders believed, depended on a flow of eastern money. When the convention adjourned, the visitors agreed that Chicago held a great deal of promise, but for now it didn't quite measure up. The city remained an open town, a frontier outpost rife with gambling and prostitution where most crime went unreported—just as well, as only a handful of constables were available to enforce the law. Then came the foreign element, those drunken, troublemaking Germans and Irish whom the ruling elite considered an impediment to any appeal to investors. No one outside Chicago apparently voiced these misgivings publicly, but it became an article of faith among the gentry that the immigrants needed to be kept under control to make the city safe for business development.

William Ogden had seen his dream of a railroad deferred but not denied. In 1848, the year the I&M Canal opened, a thirdhand locomotive dubbed the Pioneer made a ceremonial round-trip from Chicago to what is now the contiguous western suburb of Oak Park, a run of about ten miles. The

HOW LAGER STRUCK A BLOW FOR LIBERTY

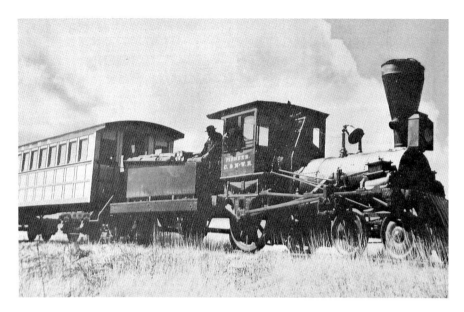

The first Chicago trip of the Pioneer locomotive in 1848 extended only ten miles but set the city on track to become the premier rail center of the nation. *Courtesy of the Chicago Public Library.*

Pioneer carried the figurative colors and the directors of the Galena and Chicago Union Railway, who rode on improvised seats in the freight cars. Along the way, the party noticed a farmer driving a wagon load of wheat along a rough dirt road. Someone on the train had a brainstorm. The farmer agreed to have his wheat loaded into one of the cars, and in less than an hour, it arrived safely at the end of the line. A new chapter had been written. A month later, the Pioneer began hauling loads of wheat from the Des Plaines River, bypassing the canal route. The young city's distinction as a premier rail center was off and chugging.

By 1852, four more rail lines were in operation, two connecting with the East, one with the South and another with the West. The most notable of these carriers was the one directed south, the Illinois Central (IC). The company's quest for a lakefront right-of-way into the city was marked by a few years of struggle between politicians and capitalists who may have had objectives beyond civic improvement. Wentworth, for example, crusaded in favor of the railroad on the pages of his newspaper, *The Democrat*, maintaining that the supposedly generous terms being offered would create jobs and save tax money by having the IC pay for lakefront improvements such as dikes and seawalls. (His involvement occurred during a two-year period in which he did not hold political office.) Bessie Louise Pierce suggested that

The Great Chicago Beer Riot

Wentworth's ownership of a sizeable block of IC stock might have had something to do with his enthusiasm.

Senator Douglas, a participant in the city's negotiations with the IC, had bought land from the railroad on which he planned to build an extensive estate called Oakenwald overlooking Lake Michigan. Setting aside arguments that the right-of-way would despoil the lakefront, voters approved a referendum on the question only to see it vetoed by Mayor Walter Gurnee. Pierce wrote that "[t]he Mayor's motives were also [suspect] because he lived on Michigan Avenue among wealthy Chicagoans who feared that the proximity of a railroad would bring down the price of their property." The controversy dragged on until June 1852, when the common council, after intervention by Douglas, passed an ordinance acceptable to all parties. The senator's long-cherished dream of a rail link between Chicago and the Gulf of Mexico would become a reality. By 1856, Chicago was the hub of ten lines spanning more than three thousand miles of track that brought thirty-eight freight and fifty-eight passenger trains into and out of the city daily. At the outbreak of the Civil War in 1861, more railroads converged on Chicago than at any other location on the planet.

Chicago's achievements during the remarkable year of 1848 went on and on, as if in step with the dramatic changes occurring elsewhere in the

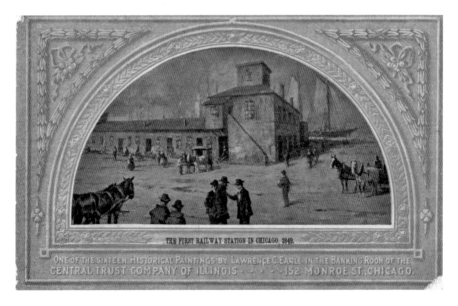

Chicago's first railroad station. By 1856, fifty-eight passenger trains were chugging into and out of the city daily. *Courtesy of Chicago Public Library, Special Collections and Preservation Division, CCW 11.10.*

nation and the world. Famine and revolution continued to move toward their tragic conclusions in Europe. American women were reasserting their rights to equal citizenship. Emerging victorious from the war with Mexico, the United States annexed by treaty the present-day states of California, Nevada, Utah, most of Arizona, half of New Mexico, nearly half of Colorado and the southwestern section of Wyoming. Two weeks into 1848, the year of Chicago's birth as a modern city, the first telegraph message flashed across the line from Milwaukee to its neighbor to the south. On March 4, the city's eleventh birthday, its citizens took a socially progressive step when they went to the polls to vote in a referendum on several proposed clauses to a new state constitution. Voters rejected a proposal that would have prohibited blacks entering the state or slave masters bringing them in for the purpose of freeing them. Unfortunately, Illinois would not go so far as to repeal its Black Laws until 1864. This set of laws prevented blacks from voting or owning property and essentially declared that they enjoyed no legal standing within the state.

As the weather warmed in 1848, the first boat passed through the newly opened I&M Canal en route to Lake Michigan. From the opposite direction, the Chicago River welcomed the oceangoing English ship *Ireland*, arriving from Montreal. "This opens a new trade for the city," *The Democrat* exclaimed, "as goods can now be shipped from Chicago to Liverpool without transshipment." Buildings were going up at an average rate of six hundred per year. In rooms above a flour store near the river, Chicago's board of trade—home of the cacophonous trading pit where grain, livestock and other commodities were bought and sold—got its start. Some of the cattle would pass through another enterprise begun in 1848: the city's first stockyard. (Chicago's sprawling Union Stock Yards wouldn't open until Christmas Day 1865.) Cattle and grain made their way into the city on the first wooden turnpikes that extended to the countryside. The McCormick reaper works set up shop, after relocating from the Shenandoah Valley, to build machines that would harvest the grain. Several hundred newly hired workers began assembling 1,500 to 2,000 reapers each harvesting season. Grain poured into the city aboard wagons, railcars and barges. Some of the harvests found their way to the city's first steam-powered grain elevator.

This explosion of progress didn't end with the turn of the calendar page. Gas illuminated the city for the first time on an afternoon in early September 1850. A little publication called *The Gem of the Prairie* reported that "brilliant torches flamed on both sides of Lake Street as far as the eye could see… In the evening the lamps were again lighted, and for the first time in the

THE GREAT CHICAGO BEER RIOT

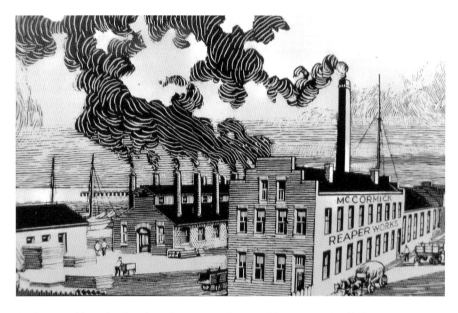

Grain poured into the city aboard wagons, railcars and barges, much of it harvested by machines built at the McCormick Reaper Works. *Courtesy of the Chicago Public Library.*

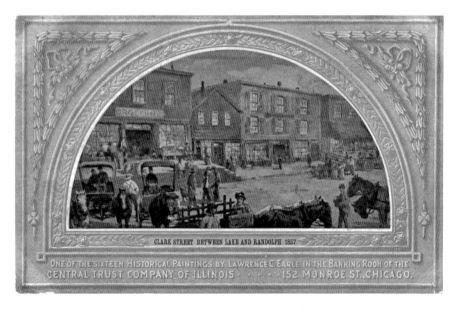

Clark Street, between Lake and Randolph Streets. Thoroughfares and sidewalks were covered with planks, often choked with dust and bathed in foul-smelling standing water. *Courtesy of Chicago Public Library, Special Collections and Preservation Division, CCW 11.13.*

history of Chicago several of the streets were illuminated in regular city style. Hereafter she would not 'hide her light under a bushel.'"

For all its advancements, Chicago struggled to pull itself out of the mud—literally as well as figuratively. A visiting writer named John Lewis Peyton reported that brick makers had discovered excellent clay beds along the lakefront and were turning out millions of bricks. Obviously, no one at that time thought of using the bricks to pave the streets. To make streets and sidewalks passable, they instead were covered with planks. Since there was little or no drainage, water accumulated under the planks across three-fourths of the city, Peyton learned. As the sewers from the cheap frame houses that stood jammed together were emptied into the standing water, "a frightful odor was emitted in the summer, causing fevers and other diseases…Sometimes the weight of a passing wagon would cause a plank to collapse and send a pool of green and black slime rising through the cracks." Some residents discarded garbage by the side of the roads. Disposal, such as it was, fell to the hogs that were allowed to roam free. No wonder Carl Schurz's rat friends found this such a welcoming environment. "In the summer," added Miller in *City of the Century*, "when the prairie winds dried the roadways, Chicago's air turned into swirling clouds of dust, and at night, until gas lights were installed…people had to use lanterns to negotiate the dangerously constructed streets, which with growth and prosperity, began to be filled with criminals, drifters and rowdy sailors and canal boatmen." After dark, only a handful of watchmen kept an eye on such characters and settled any disturbances.

The wooden buildings and sidewalks raised the never-ending likelihood of serious fire. Chicago formed a small volunteer fire department in 1836 that relied on hand pumpers and bucket brigades. Such a force proved ineffective in 1839 when the city experienced its first major fire, a blaze that destroyed the first of five Tremont House hotels along with seventeen other buildings. Fire protection always seemed one step behind the city's explosive population growth, even after the Great Fire of 1871.

The third Tremont House formed the centerpiece of a massive undertaking to raise downtown Chicago from the mud, once and for all, by seven feet. The tallest brick building in the city at five and a half stories, the Tremont posed a substantial challenge. Hotel management was eager to undertake the project, perhaps weary of watching guests sit on the front steps and shoot at the ducks that flocked to the gullies along State Street. But how to undertake the job of raising five and a half stories of brick and mortar? Accepting the challenge was George M. Pullman, barely thirty years old and destined

The Great Chicago Beer Riot

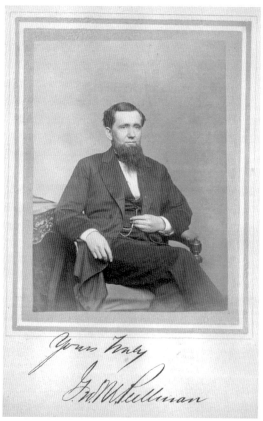

to become the founder of a railroad empire bearing his name. "I can raise your hotel without breaking a single pane of glass or stopping your business for a day," Pullman assured the Tremont's owners. In 1861, he assembled an army of 1,200 workers and posted them at even intervals around the building. To the wonderment of large crowds that gathered to witness the process, the workers synchronized the turning of five thousand jackscrews, one at a time. After seven weeks, the Tremont, supported by new wooden pilings, had risen from the mud and conformed to the new city

Top: The third of five versions of the elegant Tremont House hotel, where the city's upper crust slaked its collective thirst, even during the period of Sunday closings. *Courtesy of Chicago Public Library, Special Collections and Preservation Division, CCW 5.48.*

Left: Before he became a railcar magnate, young George M. Pullman literally raised the Tremont House out of the mud that filled downtown streets. *Courtesy of Chicago Public Library, Special Collections and Preservation Division, CCW 17.6.*

standards. True to his word, Pullman made sure that hotel business was not interrupted.

The Tremont came to typify the divide between the native and immigrant classes by the way they indulged their thirsts. While the Irish had their saloons and the Germans their *bier stubes*, *biergartens* and rathskellers, the city's elite could enjoy one of the finest hotel bars in America. The third Tremont was designed by noted New York architect John M. Van Osdel for James and Ira Couch, two brothers also from New York who spared no expense to provide comfort and convenience. Pierce revealed that the furnishings in the Tremont were reputed to have cost $30,000, a staggering amount for the times. The place was adorned with mantels of Egyptian marble, rosewood and mahogany chairs and silk-lined damask curtains. Each room came equipped with an annunciator and speaking tube. The hotel became one of the first establishments of any kind in the city to introduce steam heat and gas lighting. According to an 1851 periodical, the Tremont's "internal arrangements, including furniture and decorations, are all in the highest style of art, and of the class dominated princely." All in all, not bad for what was still a rough frontier city.

The site of many gala banquets and balls, the Tremont held an annual invitation-only Thanksgiving Day dinner of game dishes such as quail, pheasant, venison, mountain sheep and, on occasion, buffalo hump and bear steak. In 1852, the hotel played host to a ball sponsored by the city's Old Settlers, an exclusive club that claimed the likes of Ogden, Wentworth, Gurnee and John H. Kinzie, son of Chicago's first Caucasian resident. Two years earlier, the Tremont had installed an elegant music hall that was bathed in light from hanging gas chandeliers. Featured performers included the new Chicago Philharmonic Orchestra, as well as the famed "Swedish Nightingale," Jenny Lind.

Prominent citizens who gathered regularly at the Tremont's well-appointed barroom would "pass the evening imbibing moderately of wine and whiskey and relating stories," in the words of one of the habitués. It's interesting that he didn't mention beer, the preferred beverage of the German immigrant. While nearly all of the city's Irish population were members of the working class, a small gentry did exist, and some of them could be found mingling with the Tremont regulars. Foremost was Dr. William Bradshaw Egan, one of Chicago's earliest physicians, who arrived in town in 1833 and, like so many other notable men, also dealt in real estate. Regarded as an Irish gentleman, a classical scholar and an authority on Shakespeare, Egan was one of the founders of the Sons of the Emerald Isle, a group created in 1842

to work for repeal of Ireland's union with Great Britain. His intellectual pursuits led him to a "strange bedfellows" association with that other doctor, Levi Boone, when they and other cultural devotees founded the short-lived Chicago Lyceum in the mid-1830s. Two additional Tremont regulars, brewer and gentleman farmer James Carney and attorney Patrick Ballingal, were charter members of the Sons of the Emerald Isle.

The Sons weren't concerned only with international politics. In 1843, they participated in Chicago's first St. Patrick's Day celebration. Others in the informal Tremont group included David S. Stewart, lawyer and onetime U.S. congressman; Dan McIlroy, state's attorney in the mid-1840s; Captain Jim Smith, a lumber merchant; attorney Andrew Harris; and S. Lisle Smith, a distinguished Whig who delivered a eulogy at the funeral of Henry Clay. Ogden and Wentworth dropped by occasionally, although "Long John" "preferred to drink at the local taverns with Hoosiers and stevedores," according to Miller. Wentworth's appetite for whiskey and food nearly equaled his thirst for making money. "My doctrine is this," he proclaimed, "eat when you're hungry, drink when you're thirsty, sleep when you're sleepy, and get up when you're ready." A Wentworth dinner might consist of soup, fish, a roast, plenty of vegetables and bread pudding for dessert, said his biographer, Don E. Fehrenbacher. As he grew older, Wentworth saw his beverage of choice changed from whiskey to champagne then to Rhine wine on doctor's orders. He never drank beer. "It's nasty stuff, makes you soggy and fat and lazy, and I don't want to be either."

The most distinguished Tremont visitor of all, and very likely its champion imbiber, was Senator Douglas, the "Little Giant." At barely five feet tall and weighing not much more than one hundred pounds, he stood scarcely taller than Wentworth's belt buckle. Yet the little fellow could knock 'em back with the best of men. "In a day of hard drinking, when candidates were expected both to provide and consume more whiskey than their opponents, he rarely came off second best," Gerald M. Capers disclosed in *Stephen A. Douglas: Defender of the Union*. Before his first marriage at age thirty-four, "He was more often to be found with the boys in the bar, the newspaper office, or the lobby of the capitol than at his own desk."

Tales of Douglas's escapades abounded. Celebrating the election to office of a mutual friend, "he and General James Shields danced the whole length of the table, singing and kicking off dishes," Capers related. Wherever he rested his elbow, he made great company. A newspaperman of the time observed that the senator "can talk religion with priests as well as politics with the statesman." Douglas himself would have been the first to agree. "I

live with my constituents, eat with my constituents, drink with them, lodge with them, pray with them, laugh, hunt, dance and work with them." Voters responded in kind. Except for a period when he was sponsoring highly controversial legislation, Stephen Douglas was the most popular political figure in Illinois. He stopped regularly at the Tremont, made it his permanent residence for a while and died there in 1861.

The senator's companions at the Tremont, by and large, were members of what's been called Chicago's prairie or frontier aristocracy. They were by no means the type of aristocrats that the Germans and Irish had to deal with back home. "Blood and background counted for little," Miller maintained, "since so few members of the inner circle came from well-connected families." He mentioned as an example an early hardware merchant who said that all he knew of his father was that he was an honest man. Of the city's first nineteen mayors, only two, a blacksmith and a barkeep, were not part of the business class. These prairie aristocrats were self-made men, all about money, a lot of it made in real estate.

Chicago was a "city on the make" long before Nelson Algren coined that term. A man's bank balance was his admission ticket to the next level up. Long John Wentworth proved a case in point. Those who first encountered him as a twenty-one-year-old, arriving on foot in 1836 with his drying boots and a jug of whiskey in hand, couldn't have expected much. But the six-foot-six three-hundred-pounder also brought along a degree from Dartmouth College, a letter of introduction from the governor of New Hampshire and a fierce determination to succeed. Within five years, Wentworth had apprenticed in a law office, obtained a law degree, been admitted to the bar and was on his way to Congress. With the help of financial backers, he bought the *Chicago Democrat* and became its editor just one month after arriving in town. He became sole owner in 1839. He made millions in railroads and real estate and built a mansion yet never really shook off the dust that covered him when he strode into town. Considered vulgar by some in polite circles, Wentworth still got invited to the house parties that formed the core of early Chicago society's entertainment. Members of the New England Society of Chicago, for instance, organized soirees that included an annual event observing the Pilgrims' landing at Plymouth Rock. Yankee loyalties didn't run much deeper.

"Undeniably, the little city was crude," admitted Paul Gilbert and Charles Lee Bryson in *Chicago and Its Makers*. "But just as undeniably it contained in embryo all the elements of a splendid culture…There were no operas, no art colony, no great university, no organizations of the educated and refined…

yet there were neighborhood gatherings, literary societies, sectional clubs and always the churches."

The locus of upper-class social activity, in Miller's estimation, was Ogden's Greek Revival mansion, which stood on four acres at the edge of town. The estate was designed by John Van Osdel, the New York architect who did the third Tremont House. "There, drink in hand, [Ogden] would entertain guests around a blazing fire," play the piano and lead everyone in singing. Famous visitors over the years came from far and near and represented many from the fields of politics and literature. Former president Martin Van Buren enjoyed the Ogden hospitality, as did future presidential candidate Samuel Tilden and Senator Daniel Webster. Poet Ralph Waldo Emerson and his friend and fellow transcendentalist Margaret Fuller, the feminist writer, visited in 1843 during their tour of the Midwest. Chicago was still a comparatively small place, but the Ogden estate stood worlds apart from the "shanties and rookeries" of those "poor and vicious foreigners."

GEMULTLICHTKELT UND POLITIK

Since William Ogden had his hand in practically every other enterprise in early Chicago, why not brewing as well? Beer and brewing seemed to run in his blood, noted Bob Skilnik in *The History of Beer and Brewing in Chicago, 1833–1978*. In 1836, Ogden bought a part interest in Chicago's first full-scale commercial brewery, started three years earlier by German immigrants William Haas and Conrad Sulzer. Haas and Sulzer apparently had seen opportunity where other entrepreneurs saw only a rough frontier outpost with a population of a few hundred. Before the partners' arrival by way of Watertown, New York, with malt, barrels, brewing equipment and $300 cash, Chicago beer drinkers were dependent on two primitive taverns that made their own ale. Sometimes the home brew would get supplemented by a shipment from the East—no doubt a festive occasion akin to the annual arrival of *Beaujolais nouveau* in France.

More brew masters set up shop to quench young Chicago's seemingly unquenchable thirst. Ogden sold his interest in the Haas operation to German immigrant Michael Diversey in about 1841. The ex-mayor jumped back in six years later when he became a silent partner to John A. Huck and John Schneider after first selling the land for the brewery to the partners. Ogden later wrote that "[m]y brewery is the only thing that makes money without trouble." Skilnik called the Huck enterprise "[t]he most significant new brewery established during this pioneering period… the first true lager beer brewery in Chicago." Lager differed from the ale to which most Chicago beer drinkers were accustomed in both taste and

brewing technique. Initial reactions of the native-born were unenthusiastic, Skilnik related, because many harbored "a distrust and suspicion of anything foreign." Ale represented the status quo and all things English. "Lager beer represented the unfamiliar, the foreign, [and] the Germans," who conversely saw the brew as "a taste of home, a social lubricant…to be enjoyed with friends and family."

In keeping with the spirit of *gemultlichkelt*, Huck opened Chicago's first beer garden at the corner of State and Banks on the North Side. The place later adopted the name Ogden's Grove. A bit farther north, in the early 1850s, saloons could be found on almost every corner of what came to be known as Old Town, said Shirley Baugher in *Hidden History of Old Town*. This district west of Clark Street and north of North Avenue was home to early German immigrants who cultivated small plots that produced potatoes, celery and especially cabbages, so many of the latter that the area was called the "Cabbage Patch." Here the *burghers* also planted small single-family cottages, and the neighborhood saloon followed. In 1855, Klugel's Lager Beer Saloon appeared at 1623 North Wells Street and became a favorite of the local population, Baugher noted. She pointed out that such establishments offered more than a spot to down a beer. "They were community centers where neighbors got together and shared news and concerns. They served as social clubs, gathering places and a lifeline to the old country." The bartender or owner often provided an ear for family troubles, as well as a little cash to lend to patrons down on their luck.

Some taverns functioned as informal employment agencies and supplied German newspapers to

The North Wells Street site of Klugel's Lager Beer Saloon, one of the earliest German neighborhood taverns, remains a bar and restaurant today. *Photo by John F. Hogan.*

those who couldn't read English or simply preferred their native language. In other words, far from breeding disorder, the German neighborhood saloon stood as a community anchor. Typically it was owned and operated by a responsible businessman. The last thing an owner needed was rowdy drunks who could cause property damage or trouble with the authorities. Nevertheless, as Sam Mitrani wrote in *The Rise of the Chicago Police Department: Class and Conflict, 1850–1894*, "The city's native-born businessmen and politicians felt genuinely threatened by the drinking and perceived disorder of the immigrant neighborhoods," and one of the principal reasons they expanded the police force in the mid-1850s was to contain this perceived problem. Immigrant workingmen lived their daily lives outside the direct control or supervision of civil authority, and the ruling class didn't like it.

The appearance of the ethnic saloon represented a relatively new development in mid-nineteenth-century America. In earlier years, it wasn't uncommon to find men of various races and nationalities, apprentices and master craftsmen, drinking together in the same tavern and discussing politics, religion and other topics of the day, Mitrani noted. Saloons segregated by class and ethnicity, he stated, "gave workers the chance to socialize free from elite eyes." To Levi Boone and like-minded anti-immigrant, pro-temperance individuals, this freedom made the immigrant workingman and his drinking customs a potential threat to the established order. Who knew what they might be cooking up? A temperance advocate lamented that drinking establishments in 1854 Chicago outnumbered churches seventeen to one. Clearly, in his opinion and that of others, too many were enjoying themselves on their days off, even if they did so after attending Sunday services.

An article in *Der Westen* describes a Sunday outing in Ogden's Grove:

> *Sunshine, woodland green and woodland shade, the sound of horns! On a Sunday afternoon, what more could a German heart possibly wish for?! A good mug of beer!...Cheerful groups everywhere, families and their friends taking of Sunday afternoon nectar...There, in all the different dialects of our dear German homeland, chattering and blabbering and groups of young and old men and boys drinking beer...Ha! The Germans like nothing better than a party under the oaks! The life our forefathers had in the woods still clings to us.*

This portrait of beer linking young and old from different regions with nature, tradition and a good time could serve as a template for a twenty-first-century television commercial. Just add the brand name. The image defies

the "propaganda of the moralists and the churchmen" (to use Bessie Pierce's expression), who were convinced that alcohol consumption formed the root of most of the evils and unrest of the times. Chicago churches welcomed a succession of temperance organizations delivering moral arguments against "Demon Rum." Among the crusaders were the Washington Temperance Society, the Bands of Hope, the Chicago Juvenile Temperance Society, the Total Abstinence Benevolent Society, the Good Templars and the Scottish Temperance Society. They had their work cut out. By 1830, the average American over the age of fifteen already was consuming the equivalent of nearly seven gallons of pure alcohol per year, three times the level of 2014.

Chicago began licensing the sale of liquor in 1837, the year of the city's birth, although enforcement was spotty. Those who purchased licenses soon began to complain that they were being placed at a competitive disadvantage by those who ignored the law, as the cost of a license typically got passed through to the consumer. In 1841, historian Einhorn calculated that there were fifty-two liquor retailers in the city but only twenty-nine had purchased licenses; seventeen of those were hotels.

The years immediately ahead saw a rise in anti-liquor sentiment that was reflected by common council action in 1846 to form a new license committee. Levi Boone, then alderman of the Fourth Ward, was named chairman with the understanding that he would set aside his efforts to ban liquor and abide by the will of the committee's majority. An annual fee of fifty dollars remained in place. That arrangement worked well for five years. The committee approved licenses and assessed fines for violations, such as sales to minors or allowing gambling on the premises. The sale of liquor to women also was prohibited.

The aldermanic accord began to fray in 1851, when the anti-liquor bloc insisted on raising the cost of a license to $100. The antis argued that "poverty, crime and wretchedness" caused by alcohol consumption raised taxes and depressed the value of property in the vicinity of saloons. Their opponents countered with a classism argument: a higher license fee would allow only the rich to sell liquor and perhaps even consume it because of the pass-through costs. Maybe that was the intent of the proposed hike. After much contentious debate, the "low license" faction prevailed. Boone resigned as chairman, but any regrets of his and his allies undoubtedly were soothed if not eliminated by something that happened in Maine the following month. That state approved a law prohibiting the sale of liquor except for strictly medicinal purposes.

Enactment of the Maine Law supercharged the ranks of the prohibition-minded. Organizations called Maine Law Alliances sprouted up in a

How Lager Struck a Blow for Liberty

number of states with Protestant clergymen in the forefront. Several eastern states adopted laws based on the Maine prototype. New York's entry into the prohibition column can be attributed in part to the work of Stanton's and Anthony's Women's State Temperance Society. Prior to the 1854 elections, that group laid out a nine-point get-out-the-vote plan to elect sympathetic tickets and candidates who could serve as contemporary models. The strategy called for a statewide organization subdivided down to the ward and school district levels. Rounds of meetings, committees of correspondence and a statewide convention were to be followed by women marching en masse to the polls on election day to urge the selection of temperance candidates, even though the enthusiasts themselves weren't allowed to vote.

Before jumping on the Maine Law bandwagon, Illinois, through its legislature, had made a number of futile attempts to restrict the sale of liquor. The most notable was a law that prohibited the sale of wine or liquor in quantities of less than one quart. The measure defied the very concept of a tavern by further banning the consumption of alcohol on the premises where it was sold. It also forbade sales to anyone under eighteen. Lack of enforcement and open defiance of these restrictions became so widespread that they collapsed of their own weight. Equally useless, according to historian Einhorn, was a state-approved license ban aimed specifically at Chicago. Undaunted, the anti-liquor forces focused on the upcoming municipal elections in March 1852. They fielded a full slate of candidates headed by Amos Throop for mayor. Throop finished third as Mayor Gurnee cruised to reelection.

In December 1853, a proclamation addressed to the "People of Illinois," signed by twenty-three leading citizens from throughout the state, called for a mass meeting at Chicago's South Market Hall to establish an Illinois State Maine Law Alliance. The time had come, the clarion call declared, to end the "intemperance…annually sweeping its thousands of victims into graves of prematurity." The organization pledged to elect a Maine Law legislature in the November 1854 elections.

Some 240 delegates from twenty-four counties, more than 80 percent clergymen, gathered on January 19, 1854, to organize the alliance and put their plans in motion. The convention's wrap-up report conservatively estimated that 600 wholesale and retail liquor establishments existed in Chicago. Of that number, the report further estimated that 388 were unlicensed. In some places, it was noted, saloons took up entire blocks and served both men and women. About 40 percent of the saloons, the report speculated, offered some form of gambling. Lecturing that "intemperance

and licentiousness are almost inseparable," the alliance claimed that the city contained ten brothels. That estimate may have been low, but one statistic less open to challenge was the existence of three distilleries and ten breweries.

A fundamental precept of the new alliance bound its members to never vote for a candidate who was "not unequivocally pledged to the Maine Law," historian Pierce observed. Putting this conviction into practice, they got behind Amos Throop's second bid for mayor in the March 1854 election. Throop didn't fare any better than he did two years earlier, losing to Isaac Milliken, a blacksmith.

While the moral reformers opposed liquor in all its manifestations, they expressed particular concern about drinking on Sunday. Kyle G. Volk asserted in *Majority Rule, Minority Rights* that "Sabbath reformers and others insisted that…the state needed to promote Sabbath observance and protect citizens' ability to peacefully worship…Sunday laws venerated the intentions of the American republic's founders," they maintained, in the erroneous belief that the founding fathers "sought to establish a Christian nation… Since an overwhelming majority of Americans were Sunday-celebrating Christians, did it not follow, they asked, that state and local governments could promote Sabbath observance, shield the day from desecration, and protect the majority's ability to worship peacefully?"

In their zeal to keep the Lord's Day holy, reformers extended their crusade to the railroads. May 1854 saw delegates from nearly every western state hold a Sabbath Convention in Chicago. They demanded legislation to enforce the observance of the Christian Sabbath. In particular, they wanted trains to stop running on Sunday. They already had found an ally in the *Chicago Tribune*, which editorialized in June 1853 about a Sunday run by the Rock Island from Chicago to La Salle, Illinois, and back. Calling the two-hundred-mile round trip a "profanation of the Sabbath" and an attempt to "break down our religious institutions," the newspaper argued that the trip wasn't necessary because the line could accommodate the public on the other days of the week. The *Tribune* stopped short of calling it divine retribution but pointed out that the run was marred by an accident that didn't injure anyone but rather caused the engine's smokestack to get "knocked to pieces." After the *Trib* had had its say and after the convention delegates left town, trains continued to run into and out of Chicago seven days a week.

Like any frontier town, Chicago from its beginnings experienced its share of drunkenness, disorder, brawls, robberies and other incidents. About midcentury, a new trend began to appear: the emergence of like-minded people coalescing around a social or political objective and engaging in

How Lager Struck a Blow for Liberty

street demonstrations, civil disobedience or stronger measures to press their case. Such activity was hardly new, of course, as the Forty-Eighters could well attest; it was just new to Chicago. Much of the activism was driven by national developments related to the slavery issue.

Southern slave owners in 1850 prevailed on their numerous allies in Congress to significantly strengthen a law that had been in force since the time of George Washington. The original law simply allowed slaveholders to recapture any slaves who managed to escape. The Fugitive Slave Law of 1850 provided some teeth, placing the full force of the government, from the courts to the army, behind the act. It further commanded every American, in effect, to become a potential slave catcher. Aiding an escapee was punishable by a jail term. Anyone refusing to assist a U.S. marshal in the capture of a runaway could be declared guilty of treason. Two Quakers actually were prosecuted for treason for refusing to participate in a slave hunt, according to a *Tribune* retrospective that mentions neither the outcome nor the state in which the case occurred. Like many legislative acts, the Fugitive Slave Law was born from a compromise, one that allowed Oregon to join the Union as a free state. That master of compromise, Senator Douglas, voted for the slave law and instantly became a pariah back home, where antislavery sentiment was building.

To say that the Fugitive Slave Law became to northerners one of the most unpopular acts ever approved by Congress might be an understatement. The act created a deep feeling of resentment throughout the North, which had "settled into a permanent conviction that slavery must be exterminated," J. Seymour Currey wrote in *Chicago: Its History and Its Builders*. Some northern states began passing legislation declaring the act unconstitutional. Wisconsin threatened to secede from the Union if the law were enforced within its borders. Chicago joined the chorus but only after a bit of prodding.

On September 30, 1850, more than three hundred black Chicagoans, more than 75 percent of the city's entire African American population, assembled at Chicago's first black church, Quinn Chapel AME on Wells Street near Washington Street, to protest the act. The featured speaker was John Jones, prosperous tailor and community leader who would later become the city's first black elected official when he joined the county board. Jones declared, "Resistance to tyrants is obedience to God. We will stand by our liberty at the expense of our lives and will not consent to be taken into slavery or permit our brethren to be taken." To demonstrate the seriousness of Jones's words, the group formed a forty-two-member vigilance committee whose assignment was to patrol the city at night to watch for slave catchers.

The Great Chicago Beer Riot

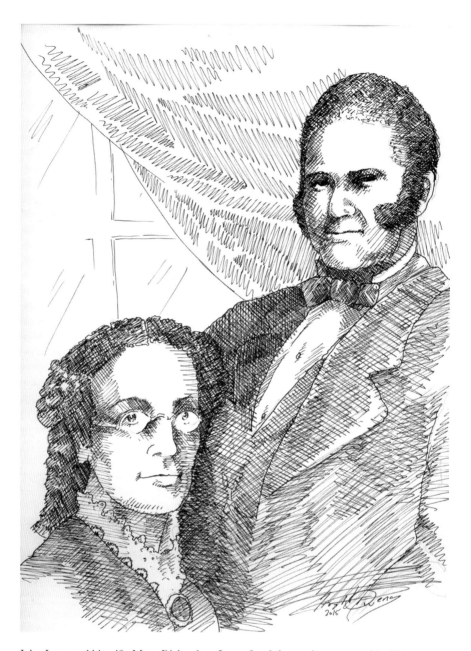

John Jones and his wife, Mary Richardson Jones, freed slaves who prospered in Chicago and were active in the Underground Railroad. John Jones became the city's first black elected official when he won a seat on the Cook County Board. *Courtesy of Matthew Owens©*.

How Lager Struck a Blow for Liberty

White Chicago's turn came three weeks later. On October 21, the common council approved a resolution that set aside the Fugitive Slave Law. The following evening, hundreds of whites as well as blacks crowded into city hall to enthusiastically endorse the council's action. One speaker cried, "Damnation eternal to those who voted for or dodged the vote on the infamous slave bill." He drew cheers when he stomped on a copy of the law. The language of the council resolution rhetorically stomped on the northern lawmakers who voted for the bill, comparing them to Benedict Arnold and Judas Iscariot.

The goal of the Fugitive Slave Law was to curtail the Underground Railroad, that semi-secret network that shepherded runaway slaves across the Ohio River and moved them from safe house to safe house until they reached the terminus in Chicago. Here, as many as fifteen to twenty at a time boarded lake boats that took them to Canada and safety under British law. "No slave was ever taken back once he reached the city," historian Lloyd Lewis asserted. "No other city, unless it be Philadelphia, was so kind to the colored man." Lewis noted that U.S. marshals who tried to recapture runaways "were mobbed by citizens while the police laughed." Chicagoans who refused to obey an unjust federal law of this gravity would have no problem five years later defying local impositions on their drinking customs.

John Jones, who addressed the Quinn Chapel mass meeting, served as a link between African Americans and white abolitionists. He and his wife, Mary Richardson Jones, who was also a women's rights advocate, were both of mixed-race heritage. The couple's home at 116 Edinah Street (now Plymouth Court) became an Underground Railroad station and a gathering place for those active in the abolition movement. Longtime friend Frederick Douglass was a frequent visitor. John Brown and his band of militants stopped there in 1859 on their way to their disastrous raid on the U.S. arsenal at Harper's Ferry, Virginia. (Mary warned Brown that he was putting himself and his men in grave danger, but the abolitionist said he didn't care, according to an account written years later by Jones's granddaughter.)

A seemingly unlikely guest at the Jones home was Allan Pinkerton, the sleuth who founded the famed detective agency bearing his name. Given the nature of his profession and his later career as a maniacal union-buster and strikebreaker, Pinkerton would have seemed more attuned to catching runaway slaves than helping them escape. In fact, tracking down outlaws and other fugitives formed part of his business. Yet here stood another man of contradictions—a fierce abolitionist who had operated an Underground Railroad station in Downstate Alton before coming to Chicago but who just

as fervently considered organized labor the work of the devil or close to it. A flinty Scot, Pinkerton believed that hard work produced its own rewards. He had no problem with beer. When he arrived in Chicago in the early 1840s, he worked for about a year at the Lill Brewery. A man of such rabid beliefs who also happened to track down criminals for a living was bound to make enemies. In September 1853, someone tried to assassinate him on a downtown street, but the details have not survived. Perhaps it was only a coincidence, but one month earlier, Chicago had confronted its first strike.

The strike itself wasn't as remarkable as the business community's reaction to it: a demand for immediate government intervention against workers making a reasonable request. On the first Saturday of August, several hundred workers walked off their jobs in what would be called in later years a wildcat strike. The strikers, who were mostly construction workers, marched through downtown streets demanding an eight-hour day—on Saturday! The following Monday, after they succeeded in shutting down most of the building sites in the city, their employers appealed to the common council for help. Workers who refused to join the walkout were being threatened—some with their lives, the bosses claimed. Peace and the good order of the city were being threatened along with "the pecuniary interests of many of our citizens." Sam Mitrani stated that "[f]or the first time, employers invoked the rhetoric of disorder in order to prompt the police to protect their financial interests. But the police were incapable of putting down the strike," as they lacked sufficient manpower.

As things turned out, the employers didn't need the police to bring about a conclusion. Fifty business establishments that employed about two thousand workers banded together and vowed never to yield to "so unjust and unreasonable demand" as an eight-hour workday on Saturday. For reasons that remain unclear, the workers blinked. By the end of the week, a majority was back on the job, and by the following week, the strike had been completely broken. Mitrani maintained that the threat of future disorder motivated the city to increase the size of the police force to fifty-five, or approximately double in number, six months later. That level, however, still would prove inadequate to control far angrier mass demonstrations in the near future.

THE LITTLE GIANT STANDS TALL

Vastly overshadowed, physically as well as historically, by his rival Lincoln, Stephen A. Douglas nonetheless loomed as the dominant figure of Illinois politics in the 1850s. From the time he was first elected to the U.S. House in 1843 until he was defeated by Lincoln in the four-way presidential race of 1860, Douglas never lost an election. He could claim a fiercely loyal core following, especially among the Irish and German immigrants whose causes he championed. The Little Giant was a paradigm of political resiliency, overcoming the backlash against his support of the Fugitive Slave Law to win reelection. But the outcome didn't represent a totally accurate barometer of public sentiment because U.S. senators were elected by their state legislatures. Reclaiming lost support would become much more difficult for Douglas after he authored the explosive Kansas-Nebraska Act of 1854. If he had been running for reelection that year instead of two years earlier, the outcome might have been very much in doubt.

Stephen Douglas essentially was a libertarian. He believed that, within reason, people should be allowed to choose their own way. If a man wanted a drink, that was his business, not the government's. If his Mississippi-born first wife, Martha Reid, owned 150 slaves—which she did—apparently that was all right, too. Projected onto a much grander stage, the "Douglas Doctrine" espoused the principle of popular sovereignty with regard to the question of slavery. He was a staunch believer in compromise and felt that the fairest way to determine whether a territory entered the Union as a slave state or free state was to let its own citizens decide. The Douglas

The Great Chicago Beer Riot

Doctrine proclaimed the "right of all the territories...acting through the legally and fairly expressed will of a majority of actual residents...to form a Constitution, with or without domestic slavery, and be admitted into the Union upon terms of perfect equality with the other states."

The Kansas-Nebraska Act allowed Kansas to become a slave state if a majority of its voters favored slavery at the time it applied for statehood. The act also contained a provision that upset a delicate balance that had existed for thirty-four years. Slavery now would be permitted north of a line drawn as part of the 1820 Missouri Compromise.

Douglas claimed not to care about slavery one way or another, but his attempts at compromise succeeded in displeasing both sides. Biographer Damon Wells concluded that "[h]is attempt to convert his attitude of professed amorality into a principle—popular sovereignty—found him dismissed by anti-slavery men as immoral and by pro-slavery men as unreliable." Wells believed that Douglas lost touch and failed to detect a sea change rolling across the northern United States, the "growing feeling of revulsion" toward slavery. He "overlooked how much Americans could care once their consciences had been aroused or their way of life supposedly threatened." A *Chicago Times* retrospective twenty-three years later concluded that "[n]o man of his time had so many personal friends and so many political enemies as Stephen A. Douglas. The former regarded him almost in the light of a prophet...The latter regarded the inventor of squatter sovereignty in the light of Judas or Beelzebub, devoid of a single pure motive."

A portent of the senator's mounting problems back home occurred on January 29, 1854, the eve of Douglas's major address to the Senate on behalf of the Kansas-Nebraska bill. Georg Schneider, influential leader of the German community and editor of the *Staatszeitung*, convened the first meeting in the country to oppose the bill, as the Andreas history insisted. The meeting at Warner's Hall on Randolph near Clark adopted a number of resolutions that were forwarded to Congressman Wentworth. Long John responded by casting the first Democratic vote in the House against the measure. Soon, every newspaper in Chicago was condemning the Kansas-Nebraska bill. Schneider's leadership, though, came at a cost. A mob attacked the *Staatszeitung* offices, causing Schneider to declare that as long as he was in charge, he would defend his paper. He and his staff armed themselves and with the aid of some ordinary citizens turned back the mob without violence. Demonstrators returned to the *Staatszeitung* the following year, but again no damage to the newspaper resulted.

How Lager Struck a Blow for Liberty

Reacting to Schneider's leadership, Chicago's Germans expressed near-universal opposition to the Kansas-Nebraska bill. When Lieutenant Governor Gustave Koerner visited Chicago in February 1854, Pierce recorded, he was presented with a petition signed by several hundred of his fellow Germans. One month later, German Chicagoans met to denounce Democratic leaders who "by their sycophancy to the South called forth this outrage." They felt betrayed by Douglas and were determined to get rid of that "ambitious and dangerous demagogue" who was "a blemish upon the honor of the State of Illinois." Douglas was burned in effigy, and not for the last time.

During the winter and spring of 1854, a new political movement began to take shape in opposition to the Kansas-Nebraska bill. Its purpose was to weld a "fusion party," drawing members from abolitionist ranks across the sociopolitical spectrum. On the surface, the new party seemed noble enough, but it differed radically from others in both structure and objectives. Nicknamed the Know-Nothing Party, a name that would endure after an official change to the American Party, the organization existed as a secret society, a "dark-lantern order" in the terminology of a contemporary observer. Its name derived from the response of party members when questioned about their affiliation or aims: "I know nothing." Douglas biographer James Sheahan wrote that "[i]ts members were unknown; no man could tell whether his neighbor in the councils of his own party was or was not a member of the secret order. Men and parties were paralyzed…It sprang up rapidly."

The Know-Nothings added a mean-spirited dimension to their agenda—a fanatical hostility toward immigrants and Catholics, Irish Catholics in particular. They also championed temperance and became the only party to embrace antislavery, anti-immigration, anti-Catholicism and anti-liquor. In spite of its antislavery stance, one of the party's earliest adherents was Levi Boone, who apparently felt that three out of four wasn't bad. A man can't have everything, after all. Suddenly, Know-Nothing power and influence seemed to be everywhere. Party members seized control of cities, districts and states. A Know-Nothing candidate was elected mayor of Philadelphia in May 1854, about the same time the Kansas-Nebraska bill was winning Congressional approval. The measure cleared the House by a mere thirteen votes and was signed into law on May 30 by President Franklin Pierce, setting the table for a summer of excitement in Chicago.

On June 5, supporters of Kansas-Nebraska staged a parade in the city, but in Bessie Pierce's telling, "the line was thin and wavering" compared

with a march on the Fourth of July that brought together ethnic groups that previously had had little to do with one another. Celebrating national independence and their opposition to the new law, members of the Hibernian Society, the German Turners and the Scandinavian Union filled the streets. When these nationalities locked steps less than a year later, the day would not pass so peacefully.

The most important news that Independence Day came not from Chicago but from Philadelphia, where Senator Douglas had accepted an invitation to deliver the Democratic Party's annual oration in Independence Square. Maybe invoking a touch of hyperbole, biographer Sheahan painted a picture of Democrats getting crushed by "this new and formidable [Know-Nothing] political party." Who was to lead the counterattack, he wondered. No member of Congress was talking publicly of this new phenomenon. Into the void stepped the Little Giant to deliver the first speech by a prominent figure "against the proscriptive principles of that party." (Although James Sheahan penned a fine biography of Douglas that was published the year before the senator's death, it should be pointed out that the author, a Washington newsman, was bankrolled by Douglas in 1854 to launch a Chicago newspaper after all the other local papers had turned against him. It's been said that Sheahan was closer to Douglas than anyone outside the senator's family.)

In an address that alternately mocked and denounced the Know-Nothings, Douglas drew repeated cheers and applause as he accused the new movement of making war on the constitution, embracing its rights for themselves while denying them to others. Philadelphians laughed when Douglas pretended to "know nothing" about the secret society, only that its members professed to "know nothing" of its aims, so he had to conclude that "Know-Nothings" is their name. Seeming to express regret rather than rebuke, he acknowledged that "your city is now being managed under [Know-Nothing] auspices, and that the whole patronage of the city is distributed under its direction and in accordance with its principles" of denying government employment to persons not born in the United States. Warming to his central message, Douglas declared, "To proscribe a man in this country on account of his birthplace or religious faith is subversion to all of our ideals and principles of civil and religious freedom. It is revolting to our sense of justice and right. It is derogatory to the character of our forefathers, who were all emigrants from the Old World…They, too, suffered the torments of civil and religious persecution."

Disregarding the existence of some 4 million human beings held against their will, mostly in the South, Douglas called on his fellow Democrats to

How Lager Struck a Blow for Liberty

"be ready to fight the allied forces of Absolutism, Whigism, Nativism and religious intolerance." He closed as he began, with a defense of the Kansas-Nebraska Act, pointing out that Americans now had the opportunity to flee civil and religious persecution, as their forefathers had done; they could "find an asylum in Nebraska, where the principles of self-government have been firmly established in the organic act which recently passed Congress."

"From that day forth Know-nothingism had a stern opponent in the Democratic Party," Sheahan wrote, sounding not unlike a Douglas press secretary. "[The speech] was received by the Democracy of Philadelphia with enthusiastic delight. It broke the spell which had apparently hung over the party, and which had closed men's lips and paralyzed their hands."

The senator may have changed some minds in Philadelphia, but the folks back home in Chicago would prove far less receptive to the Little Giant's spellbinding oratory. For every one of those who greeted his comments "with enthusiastic delight, there were many others who wanted to hear no more; they wanted Douglas' lips closed," said Sheahan. After Congress adjourned on August 1, 1854, Douglas spent some time in Boston and then traveled to Chicago, able to see the way by the light of his own burning effigies, the senator later remarked sardonically.

He settled in at the Tremont House on August 25 and "found his power gone, and only a small but faithful minority of adherents left," historian Andreas related. The once invincible Democratic Party of Chicago, reflecting the troubles of the national party, had broken apart over the slavery issue. What Douglas further found, in the Sheahan version, was "a most formidable organization opposed to him…determined that under no circumstances [should he] have the opportunity to address the people." The senator was hoping to deliver a blockbuster speech that would reclaim his following, the way he did after his unpopular support for the Fugitive Slave Law four years earlier. Fearful of his oratorical skills, his opponents wanted no repetition of 1850, and the clergy, Sheahan charged, took the lead in trying to stop him. "From numerous orthodox Protestant pulpits, especially of the Methodist and Baptist persuasions, the fiat went forth to the faithful that the anti-Christ must be denied every opportunity to pollute the pure atmosphere of Illinois with his perfidious breath." Know-Nothings and their allies wanted to deny the senator's right to address his constituents on the grounds that he was a public enemy.

Once it was announced that Douglas would speak on the evening of September 1 at North Market Hall, on Michigan (later Hubbard) Street near Clark, accounts of what happened next began to differ sharply.

The Great Chicago Beer Riot

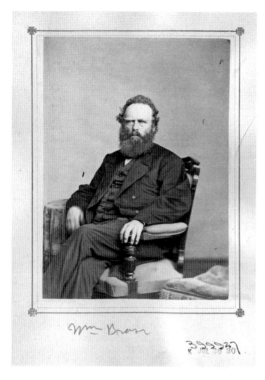

Newspaper editor William Bross used the pages of his *Democratic Press* to attack his arch-foe, Stephen Douglas, while boosting Chicago as a rising city of the future. *Courtesy of Chicago Public Library, Special Collections and Preservation Division, CCW 12.2.*

Editor William Bross, whose *Democratic Press* had been savaging the senator, said that he went to see him at the Tremont three or four days before the scheduled address to request a written copy of his remarks. Bross was a veteran civic booster of the first order and later lieutenant governor of Illinois. He said that he was received "with great courtesy and politeness" but was told that Douglas never provided advance copies of his speeches. The cordiality apparently ended there. Bross said that he learned that Douglas supporters planned to pack the hall early so others couldn't get in, pass resolutions endorsing the senator and repeal of the Missouri Compromise and make it appear that those actions represented the popular view of Chicago residents. To block this "plot," Bross noted that "substantial and order-loving people" were encouraged to turn out early.

Biographer Sheahan remembered the run-up quite differently. "A reckless, partisan press," he claimed, appealed to the public to "thwart the little demagogue's purpose." One newspaper report accused Douglas of allegedly assembling a bodyguard of five hundred armed Irishmen to compel silence while he spoke. "The fact that violence was to take place at the gathering was daily impressed upon the public by the opposition press," Sheahan contended. Such stories were planted "to inflame the Know-Nothing element," while the senator's friends sought only "fair play," even if that required "muscular backing."

September 1 arrived hot and muggy, so it was decided to move the meeting outdoors, in front of the Old Market Hall. During the afternoon,

ship owners opposed to Douglas ordered the flags of their vessels moored in the harbor lowered to half-mast. At dusk, church bells throughout the city tolled, as if for a funeral. The senator and his supporters must have realized that they were in for a rough night.

A crowd estimated at ten thousand had assembled by eight o'clock. The entire area in front of the hall was packed, and the crowd spilled onto Michigan Street between Dearborn and Clark. Spectators filled the rooftops of buildings across the street. Others stood on balconies or leaned out of windows to hear a man known to make his voice heard at great distances. Mayor Milliken had agreed to chair the meeting. Editor Bross, on hand to cover the speech, said that he was invited to sit on the stage "perhaps by Mayor Milliken." Bross added that he received a pleasant greeting from Douglas, but Sheahan wasn't deceived. "[I]t was plain from the start that a wicked feeling was abroad."

Bross claimed that the first words out of the senator's mouth constituted an insult to the press and the people of Chicago. "He charged them with not understanding so plain a proposition as the repeal of the Missouri Compromise, and the press with persistently misrepresenting and maligning him." This observation definitely was not the way to win over an already hostile audience. One is left to wonder why Douglas decided to wade into such a thicket in the first place and then throw down the gauntlet. The most likely answer was his belief in his oratorical powers, that he could convince the die-hards of the supposed wisdom of the Kansas-Nebraska Act. He immediately learned otherwise. His opening comment was met with hisses, groans and "all manner of epithets and abuse," according to Sheahan.

When the uproar died down, Douglas explained that he had come to address his constituents and had every intention of being heard. He spoke for a short while before laughing and hooting erupted. "[I]t became apparent that there was an element present," Sheahan continued, "that was not disposed to hear him." The Bross version noted that Douglas became enraged and responded with "exceedingly offensive" language. At this point, the editor told of stepping down from the stage and circulating among the audience to measure its temper. He said that he found people "happy and in the best possible humor," an observation that seemed to fly in the face of the way the evening was shaping up. Bross conceded that there probably more than one thousand revolvers in the crowd and acknowledged that "the best of humor can change to intense anger in an instant." Rumors had been circulating that every gun in town for sale had been purchased.

The Great Chicago Beer Riot

Bross returned to the platform and found himself face to face with Douglas as the hooting and yelling continued. The editor said he politely suggested that Douglas take an early exit and have his speech printed, to which the senator replied, "Mr. Bross, you see that your efforts in the *Democratic Press* to get up an armed mob to put me down have been entirely successful." Bross said he sprang to his feet and with "very emphatic gestures" replied, "Judge Douglas, that's false—every word of it is false, sir!"

"It will do very well," said Douglas, "for you with your armed mob about you to make an assertion like that."

"It's false, sir—not a word of truth in it."

During the exchange, the crowd quieted somewhat. The Little Giant resumed speaking only after he calmed his friends on the platform who had appeared ready to go after some of the hecklers. Instead, Douglas supporters formed a wall behind him and stayed there for two hours as the determined senator continued his often futile attempts to be heard. His voice rising above the din, Douglas read a letter informing him that he'd be "maltreated" if he attempted to speak. Sheahan claimed to have spoken later to men in the crowd, "armed to the teeth" and anticipating violence, who assured him that "nothing prevented bloodshed that night but the bold and defiant manner in which Douglas maintained his ground. Had he exhibited fear…his party in all probability would have been assaulted with missiles." Reports that the senator and his comrades were pelted with rotten eggs were discounted. Some said the objects were rotten apples.

At about ten o'clock, Douglas finally faced reality. His followers formed a phalanx around him, escorted him to his carriage and accompanied him back to the Tremont. Since observers close at hand agree that the boisterous meeting broke up around this time, an oft-repeated anecdote probably is apocryphal, especially since it would have had Douglas enduring an additional two hours of abuse on top of two already absorbed. This version has the mob singing, "We won't go home until morning," and the senator responding, after midnight, "It is now Sunday morning—I'll go to church and you may GO TO HELL." Whatever the hour, it's more likely that Douglas sought solace at the Tremont tap room or in his suite, surrounded by intimates, drinks in hand. His wife, Martha, mother of their two sons, had died in childbirth the year before, and the senator had returned to the earlier ways that he had forsaken in favor of marital bliss.

A shouting mob had followed the small procession as far as the Clark Street Bridge. As soon as the Douglas party crossed the river, the alert bridge tender turned the rotating span and prevented a large majority of the crowd

from continuing its pursuit. The bridge tender's tactic would be repeated with similar success the following spring under even more threatening circumstances. Sheahan considered the evening the first of many such paybacks by Know-Nothings incensed over Douglas's attack against them in Philadelphia.

The November 1854 elections were fast approaching, and Senator Douglas, although not on the ballot, was, after all, a politician. Undaunted by his hostile reception in Chicago, he embarked on a speaking tour across northern Illinois, stumping for like-minded Democratic candidates. At Waukegan, Woodstock, Freeport and Galena, the result was the same. "[H]e was greeted upon his arrival by every possible indignity…short of personal violence," Sheahan wrote—burning effigies, gallows effigies and banners carrying vulgar statements. When he attempted to speak, crowds tried to shout him down as they did in Chicago, but he managed to get his message across: the Kansas-Nebraska Act was neither proslavery nor antislavery but rather a recognition that the people of the territories held complete authority to allow or prohibit slavery within their borders.

The electorate wasn't buying. Anti-Nebraska candidates swept to victory. Along the way, temperance backers and Know-Nothings had linked their causes to the abolition movement. Except for the Know-Nothings, Einhorn pointed out, no party "could appear to champion temperance, anti-slavery or 'reform.'" It was a canny move. Candidates "fusing" these issues racked up large majorities in Indiana, Ohio, Michigan and Wisconsin. Historian Arthur Charles Cole stated that the outcome in Illinois "was more than an anti-Nebraska victory, it was a reform triumph, a temperance victory. The new legislature was a strong anti-Nebraska temperance body, anxious to secure enactment of the Maine Law." The legislature confidently scheduled a statewide referendum on temperance for June 1855.

"PICK OUT THE STARS"

Passage of the Kansas-Nebraska Act created tremors across the national political landscape that rattled Chicago particularly hard. As the Democrats split over the slavery question, with most opposing Douglas, they also found other issues, such as banking policy, on which to disagree. To their right, the ultra-conservative Whig Party was drifting further toward impotence. The Know-Nothings were poised to move into the vacuum. "[T]he spread of Know Nothingism reflected the lack of harmony prevalent in Democratic and Whig circles," Pierce maintained. The ranks of the newly hatched Know-Nothing organization in Chicago swelled with the addition of temperance and antislavery voters, disgruntled southern Whigs and, in Lloyd Lewis's words, "even liberal men, who welcomed an opportunity to avoid the slavery controversy which was rising to dominate the old Democratic and newly [developing] Republican parties." Among the more prominent of the early members was Levi Boone.

The Know-Nothings offered the perfect opportunity for Boone, allowing him to mask his proslavery views while aligning with other native-born Americans in advancing the party platform of protecting "American institutions from the insidious wiles of foreigners," specifically Catholic foreigners. While the Irish remained the primary target of the Know-Nothings, the organization extended "its proscriptions outside the religious boundaries…and struck at the Chicago Germans, a majority of whom were Protestants," according to historian Lewis. "Put none but Americans on guard," the group proclaimed. Pierce noted that the strength of the Know-

The Great Chicago Beer Riot

Nothings in Chicago became apparent when the Native American Party, as it was known officially, attempted to begin a national newspaper with headquarters in the city. The paper, the *Native Citizen*, lasted only about six months, but the party didn't need its own publication when it had the *Tribune*.

Founded in 1847, the *Chicago Daily Tribune* underwent several ownership changes before 1852, when it became a Whig publication emphasizing temperance and nativism and criticizing, in the paper's own words, "the anti-republican character of the Romish church." This was a different platform than the one editor Joseph Medill, a future mayor, would pursue after taking over in June 1855. The pre-Medill *Trib* was angry, stridently anti-Irish and anti-Catholic and given to outrageously fabricated stories. For example, in the run-up to the 1852 mayoral election, it alleged that candidate Isaac Milliken would divert tax money to Catholic schools, and it published a list of Irishmen allegedly set to plunder the city. The *Trib* urged "solid men" to vote early because "by the close of the day there is no doubt that the polls in many wards will be blockaded by a bleary-eyed, drunken rabble who will try to prevent all ingress and egress by any decent persons." The rhetoric grew worse as election day drew closer. The paper invented a story about rioters who shouted, "Death to Know Nothings" and beat native-born victims "until the snow was red with their blood." Readers were told that Irish crowds routinely harassed Protestants leaving church services. Grog sellers were engaged in a conspiracy to "put down" native Americans "if they had to wade knee-deep in blood to do it."

After the sale to Medill and his partners, the *Tribune* dropped its anti-Catholicism but continued to knock the Irish. Shortly before the change of ownership, the old regime got in one last lick at the church. The paper's city editor found himself "challenged to a duel after he criticized a ship's captain for transporting the papal nuncio, the future Cardinal Bendini, on his expedition into the American wilderness." So wrote Richard Norton Smith, biographer of *Tribune* publisher Robert R. McCormick. We may safely assume the showdown never occurred.

In those days, Chicago's municipal elections were nonpartisan and devoid of campaigning. Typically, candidates didn't announce themselves until a few days before the balloting and then only through paid notices in the press. The election of 1855 was even less contentious. For starters, it "mirrored, in general, the uncertainty attending old-time political attachments," in Pierce's view. Then there was a lack of paid announcements. "Ordinarily," the *Press* commented, "the occasion is one of great interest from the issues involved—issues pertaining to the good government and substantial welfare of our

city. Today, however, there is no such issue before the people." Although the newspaper probably didn't realize it, the condition it described was the vacuum awaiting the arrival of the Know-Nothings. The *Tribune* paved the way for the newcomers' breakthrough two weeks before election day by denouncing the ticket headed by Mayor Milliken, running for reelection, as that of "the Irish, Jesuitical, Foreign Domination and American Proscription," unofficially the longest if not the most slanderous political label of the day.

Two more papers, the *Democrat* and the *Times*, printed tickets that they *thought* the Know-Nothings would field, but it was not until election day, March 6, that the group used the *Tribune* to unveil a Law and Order ticket headed by Boone for mayor. The Law and Order Party ran a full slate of candidates, for all ten council seats at stake (some incumbents weren't running because terms were staggered) plus the citywide offices of attorney, collector, treasurer, surveyor and three police court magistrates. Boone and his citywide running mates edged the Milliken ticket by winning 51 percent of the vote. In the council races, the Law and Order candidates captured seven of the ten seats. Apparently, Boone accepted his 51 percent as a mandate to attack the Catholic Church while drastically changing the way many Chicagoans chose to spend their leisure time.

Boone and his ticket mates, in essence, ran as stealth candidates in that they not only didn't discuss their program in advance, but they also did not officially announce until election day. The doctor had resigned as Fourth Ward alderman before making the race. Supporters who weren't Know-Nothings themselves most likely were swayed by two factors: a mayoral candidate who was the hero of the cholera epidemics and a party that stood for "law and order" in an untamed frontier town. The unusual quiet that preceded the election apparently produced a feeling of complacency. Irish and German voters surely would have turned out in greater numbers if they'd known what Boone had in mind for them.

Just a year earlier, Isaac Milliken, the blacksmith mayor, had offered generous words to the foreign-born in his inaugural address. Coming from different parts of Europe and speaking different languages, Milliken declared, the masses nevertheless "are law-abiding, peaceable and industrious, cheerfully submitting to good and wholesome laws…The absence of violent outbreaks and riots is the best evidence of the attachment of the masses to our institutions." A lot could change in a year. The new mayor and his allies set the dynamics in motion one week after the election.

"I cannot be blind to the existence in our midst of a powerful politico-religious organization [the Catholic Church]," Boone stated in his inaugural

remarks, "all its members owing, and its chief officers bound under oath of allegiance to…a foreign despot [the pope], [boldly] avowing the purpose of universal domination over this land, and asserting the monstrous doctrine, [whose end is] to be gained, if not by other means, by coercion and at the cost of blood itself." Seeming to borrow perversely from the Declaration of Independence, the new mayor closed by pledging to stand against "such doctrines and such schemes…and to their defeat I must cheerfully consecrate my talents, my property, and if need be my life."

In the body of his address, Boone offered the common council a double-edged sword for striking a blow against Demon Rum: the aldermen could prohibit its sale, the mayor's preferred option, or they could raise the cost of a liquor license sixfold and prohibit sales on Sunday. With regard to the first choice, he said he found it incongruous for the city to "license a part of its inhabitants to make men drunkards, and at the same time enact penal ordinances, establish courts, and maintain at heavy expense a police to punish the poor drunkard for patronizing those establishments." If the council chose to continue issuing licenses, Boone said, it should at least prevent the Sabbath from being "profaned" by those who "disregard the sacredness of that day" along with "the rights and feelings" of those who wish to observe it in the manner intended by the Almighty. Either way, Boone expected city action to be necessary only for a short duration. He confidently suggested that Illinois voters would support the upcoming June referendum on the Maine Law and make prohibition "the law of the land." Boone believed the transition would be smoother if the tougher restrictions induced liquor sellers to go out of business before the law kicked in. The mayor further believed that the lower-class saloons would be the first to go under this scenario, leaving only the better establishments—until the new law put them out of business, too.

About this time, someone realized that both the city and state already had Sunday closing laws that had never been enforced. The Illinois statute had been on the books since 1843. Boone's timing either was accidentally ironic or intended to pile insult on injury. He chose Saturday, March 17—St. Patrick's Day—to issue a proclamation notifying saloonkeepers that Sunday closings would be strictly enforced, starting tomorrow. The next day, police made numerous arrests. Some owners who might have complied with the law complained that they had received insufficient notice. A week later, the number of closings rose sharply.

In his inaugural address, Boone recommended the hiring of more policemen with "strong physical powers, sober, regular habits and known

moral integrity." He neglected to mention that they also needed to be native-born Americans. The same caveat applied to other municipal hires. One of his first official acts was to add eighty native-born "special" officers to augment the existing ranks. Concurrently, he began a purge of foreign-born police and municipal employees. How ironic that if the first two officers killed in the line of duty, Irish Catholic James Quinn and German Catholic Kasper Lauer, had been around, they undoubtedly would have lost their jobs. Boone's purge naturally incensed the Germans, Irish and other excluded nationalities while "doing nothing to abet the city's notoriously flimsy law enforcement," as James L. Merriner put it in *Grafters and Goo Goos*. Immigrant tavern owners had to be additionally angered when the new cops, who may or may not have had their own problems with foreigners, came calling to arrest them and prevent their customers from slaking their thirsts on Sunday.

With the Sunday crackdown underway, Boone and his forces turned their attention to the license fee hikes. On March 26, the council approved an increase from $50 to $300 but for a license lasting only three months, or the anticipated time before statewide prohibition presumably would begin. Liquor sellers ripped the increase as the most tyrannical measure since the Stamp Act that fueled the American Revolution. Some paid the higher fee and some opted to go out of business, as Boone had hoped, but most determined to challenge the boost in the twin courts of law and public opinion. Several historians have speculated that Boone was more interested in punishing the immigrant classes than in advancing the cause of temperance. If provocation was, indeed, his motive, he certainly got a rise from the Germans. They began a series of meetings on the North Side to map countermeasures and elected brewer John Huck as leader of an association to defend members prosecuted for violation of the law. As noted earlier, Huck was once the partner of former mayor William Ogden and owner of the city's first beer garden. On April 4, three days after all the old liquor licenses expired, some six hundred Germans met at the North Side Market Hall to raise legal defense funds.

Temperance forces weren't standing still either. Several large, enthusiastic meetings were held throughout the city. On April 13, Elder Watson of the North Western Christian Advocate delivered what was called "a very able and powerful argument in favor of prohibition" at the Clark Street Methodist Church. More such gatherings were planned, including one on the sixteenth at the Bethel Church. The *Tribune* urged readers to arrive early and secure a seat to help offset the campaign being waged by the liquor sellers, who had met that afternoon. "These land-sharks," the paper cautioned, "feel that

their craft is in danger and are quite furious in view of the passage of the Prohibitory Liquor Law."

The *Tribune* got that right. One speaker in particular had fired up the audience that afternoon at North Market Hall. The turnout seemed to surprise the reporter who covered the event, as he noted the presence of "many men of really respectable appearance." The great majority, he reassured readers, were "rum sellers or rum drinkers." The rest of his account offered a curious exercise in journalism: a column and a half about a speech in which the speaker is never identified. There's little doubt that the person was Eighth Ward alderman Stephen D. La Rue (misidentified in some histories as L.D. La Rue), newly elected to fill a vacancy in a part of the city well populated with Germans. That the paper would deliberately fail to mention La Rue by name can only be interpreted as a snub.

An auctioneer by trade, La Rue began by standing a Frederick Douglass analogy on its head. Where the abolitionist saw liquor making slaves of men, the alderman saw the men of Chicago enslaved by Mayor Boone and the council majority through the imposition of higher license fees. The mayor was pursuing this course, La Rue claimed, to goad anti-temperance people into doing something "dreadful or desperate." "But don't you go and do it now," he warned, because "that scandalous…scurrilous paper, the *Chicago Tribune*, will go and get up a long article about a bloody riot, and they'll say it was the whiskey men who did it." Instead, he encouraged everyone to descend on the courthouse on Friday, April 20, when Justice Henry L. Rucker was due to hear numerous license cases. La Rue predicted a turnout of ten thousand.

The speech drew a quick reaction from the *Tribune*, which noted that it knew the crowd didn't represent "the better class" of Germans in the city. After some additional pandering, the editorial inexplicably began referring to the Germans as Dutch, as in "Dutch grog sellers, Dutch and Irish advocates of Free Whiskey" and "Dutch and Irish" inmates of the poor house (driven there, of course, by Dutch and Irish rum sellers). A week later, no doubt following complaints from the city's Hollanders, the *Trib* ran a clarification, explaining that its use of "Dutch" applied to the Germans, not the "good citizens" from Holland.

While the Sunday arrests began immediately after Boone assumed office, enforcement of the new license requirements couldn't begin until the old permits expired on April 1. In short order, about two hundred owners and employees found themselves under arrest for either ignoring the Sunday closing law or refusing to pay the higher fee. Sunday cases were heard in the cramped

police courts that occupied the basement of the county courthouse at Clark and Randolph Streets. Representing the accused was Pat Ballingal, one of the Tremont House bar regulars. The fate of a defendant depended largely on whether he appeared before Justice Rucker or ex-mayor Milliken, who continued to hold his second post of police magistrate. Former alderman Rucker issued convictions; Milliken dismissed a number of cases.

This was not the stuff on which the fate of a municipality hung. For instance, a witness testified before Milliken that he had

Court House Square about the time of the beer riot. The site—bounded by Clark, Randolph, La Salle and Washington Streets—was occupied by city hall and the Cook County Building. *Courtesy of Chicago Public Library, Special Collections and Preservation Division, CCW 5.83.*

peered through a window of the Traveler's Home on North Water Street and saw a man behind the bar produce a bottle of what appeared to be whiskey. The witness said a man standing at the bar poured some of the liquid into a tumbler and drank it. However, the witness could not swear that the liquid was liquor, that the man behind the bar was the owner or that the man who took the drink paid for it. Case dismissed.

The proprietor of the Blue Island House on Van Buren Street stood before Milliken accused of letting one of his boarders pour something from a bottle behind the bar and drink it. Defense attorney Ballingal argued that the substance contained medicinal roots soaked in whiskey that the boarder required for his health. Case dismissed.

In Rucker's courtroom, a witness testified that he saw eight to ten persons drinking beer and playing cards on a number of Sundays in an unnamed lager beer saloon. The son of the defendant claimed that the individuals were all boarders and that the cost of the beer was included in their lodging tab. Therefore, Ballingal maintained, the saloon technically wasn't selling beer on Sunday. Rucker ruled that the spirit of the law had been violated—

The Great Chicago Beer Riot

City hall and the Cook County Building, looking northwest, as the jointly connected buildings appear today, occupy the same site as their predecessors. *Photo by John F. Hogan.*

that in order to get all the beer or liquor he wanted, all a person need do was become a boarder at such a place. The defendant was fined ten dollars. At the start of the Sunday prosecutions, Ballingal made it clear that his clients intended to appeal as high as the Illinois Supreme Court if necessary.

As these types of cases worked their way through the police courts, Sunday business continued much as usual at Chicago's better drinking establishments—those that served refreshment more "refined" than beer. At some places, side or rear entrances were used to maintain appearances. One such gathering spot for the well-off was the Lake House, which "had one of the finest bars in the city, and mixed cocktails were all the rage," wrote Ogden biographer Jack Harpster. The former mayor was believed to have chosen the Lake House for a celebration of his fiftieth birthday, June 15, 1855, days after Chicago and the rest of the state voted on the referendum to make Illinois dry. The following scene described by Harpster could have transpired on any Sunday affected by the closing law:

> *Their waiter took orders for knickerbockers, sling flips, stonewalls, pig and whistles, and perhaps even a few mint juleps. A couple of the men smoked cigarettes with their libations, another fad that was just beginning to catch*

How Lager Struck a Blow for Liberty

on in civilized society…After cocktails, the guests dined sumptuously. The Lake House was the first restaurant in the city to offer amenities like napkins and printed menus, and they shipped in fresh ingredients by rail, like oysters, oranges, and New England lobsters. When dinner was finished and the dishes cleared, the waiter probably offered fine aged sherry or port and passed out hand-rolled Caribbean cigars.

By Friday, April 20, a particularly large number of Sunday closing cases had piled up before Justice Rucker. Both sides agreed to try one case and let the others be settled by the precedent of the first. During the week, saloonkeepers and their patrons had heeded Alderman La Rue's encouragement and made preparations for a demonstration outside the courthouse. The alderman's predicted turnout of ten thousand came up a little short. About one hundred men, led by a drummer, marched through the streets and positioned themselves on Randolph Street, opposite Court House Square. There they remained until they learned that Rucker was out of town and wouldn't hear the cases until the following day. The men promised to return.

The new courthouse, which had opened two years earlier, occupied a quiet corner of a city center that remained not far from the nearest prairie. Facing Court House Square, "The old blue brick Sherman House still hung its shabby balconies over the sidewalks of Randolph and Clark Streets," according to one news account. Horse-drawn streetcars made their way down State Street as far south as Twelfth Street, while the only other car line extended west on Madison Street as far as the Bull's Head Stockyards. South of the square came Washington Street, a quiet thoroughfare that filled with churchgoers on Sunday. Washington could have been called "Ecumenical Avenue." The Baptists boasted the newest church on the street, but the Presbyterians, Methodists, Unitarians and Universalists also were represented. To the east, the street was home to modest cottages and green gardens. Mayor Boone and his family occupied a neat frame home on State, near Madison, where they could gaze upon the lawns and cabbage patches of their neighbors. It was on this bucolic setting that a large number of very angry men would descend.

On a sunny Saturday morning, some two hundred brewers, saloonkeepers and patrons, most of them German, gathered in Ogden's Grove to hear more fiery words from Alderman La Rue. At the conclusion of his remarks, about ten o'clock, a procession led by a fife and drum moved out of the park and headed toward the courthouse via the Clark Street Bridge. Operational

The Great Chicago Beer Riot

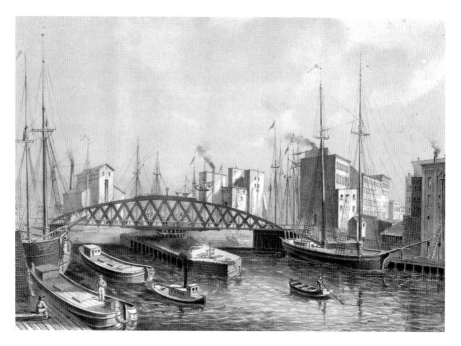

The Lake Street Bridge as it appeared in 1866 was virtually identical to the Clark Street span. *Courtesy of Chicago Public Library, Special Collections and Preservation Division, CCW 4.42.*

only since the previous Fourth of July, the bridge, 330 feet long and 30 feet wide, was the largest on the river. It featured pedestrian sidewalks and a two-lane carriageway to accommodate both north- and southbound traffic. Made of timber, the manually operated bridge pivoted on a center pier in the middle of the river, like a propeller blade. The bridge tender inserted a four- to six-foot-long iron bar into a fitting in the center of the bridge deck. The man then pushed the bar around in a circle to turn a shaft that meshed with a large gear that, in turn, rotated the bridge.

Several of the men who strode across the span carried meat cleavers and single-shot muskets. All accounts agree that the weapons notwithstanding, the marchers didn't intend violence at this point; it was their intent, following La Rue's urging, to deliver a statement about the unfairness of the law and its processes. "But there were dangerous elements at work," in the words of an anonymous eyewitness whose detailed recollections were published in the press years later. "The drums were dropping their rat-tat-tat on high-strung nerves of men who are natural soldiers [a possible reference to the Forty-Eighters]. They saw a common purpose in one another's eyes, and a spark was all that was needed to send fire through the hole."

How Lager Struck a Blow for Liberty

Two current views of the Clark Street Bridge, looking southeast and south, respectively. *Photos by John F. Hogan.*

The first arrivals swarmed into Rucker's tiny courtroom and packed it to standing room capacity. As others tried to force their way in, the vestibules filled, and later arrivals backed up on the courthouse steps. The noise they made grew more and more intense. Rucker wisely decided to adjourn court.

The Great Chicago Beer Riot

Mayor Boone, surveying the scene from his office window, grew alarmed by the sight of what seemed to be several acres of humanity occupying the entire front of Court House Square. People squeezed shoulder to shoulder from Rucker's courtroom to the front lawn made it impossible to conduct business. Acting on orders from Boone, police, led by Captain Luther Nichols, a reputed Know-Nothing, moved in to first clear the building and then the square. Officers herded the crowd into the streets, snarling traffic at the intersection of Clark and Randolph. The dispersal was accomplished without trouble.

Officers took up positions at all courthouse entrances, and order seemed restored until "a burly fellow, a little the worse for drink," attempted to force his way inside. The witness, who was standing next to Nichols at the northeast corner of the square, said that the captain took his cane by both hands, held it against the chest of the advancing man and told him he couldn't go in. The encounter touched off a short battle between the police and a small group of "rough and tumble, angry and fierce men." The drummer lost both drum heads, and eighteen of the combatants landed in the jail beneath the courthouse. Alderman La Rue, clad in a white dress coat, darted about the free-for-all in an apparent attempt to restore order. He mounted a cab whose horses were highly agitated by the battle going on around them. All La Rue could manage to say was, "My friends…" before a policeman yanked him down by the coattails and had him locked up. By noon, the mob had dispersed, but not before threatening to return, armed, to gain the release of its jailed comrades.

The marchers repaired to their saloons on North Clark and Wells Streets to salve wounded bodies and spirits with lager and stronger beverages while they planned their counterattack. During the interim, the city was swept by rumors of what the insurgents had in store. Some said that 5,000 Germans were on the way, determined to free the prisoners and burn city hall. Mayor Boone massed his entire police force around the courthouse and supplemented it with some 150 special officers recruited and deputized from nearby stores and warehouses. That brought the number of defenders to about 250. With fife and drum in the forefront, a determined band estimated as high as 500 formed up around 3:00 p.m. north of the river and advanced in semi-formation toward the Clark Street Bridge. This foray saw the Germans joined by a contingent of Irish and a smaller group of Swedes. Most carried single-shot muskets. Others came armed with pistols, clubs and meat cleavers. Reports of the advancing mob brought out some 4,000 curiosity seekers, who crowded the sidewalks, the roofs of all overlooking

How Lager Struck a Blow for Liberty

buildings and the balconies and windows of the Sherman House. The large majority came simply to gawk, but some were armed with meat cleavers, cart spokes, iron bars and heavy hammers.

By the time the marchers arrived at the bridge, a slight separation had split their ranks into two roughly equal bands. The first crossed unimpeded, but the break gave the bridge tender an opportunity to carry out an order he'd received from Mayor Boone, who was following the action from his office window, presumably with the aid of a spyglass. The operator swung the bridge open, raising a chorus of shouts, curses and threats of shooting from the protesters who'd been cut off. The bridge tender shouted back that he was following orders from the mayor. A short time later, the span was put back in place, again at the command of the mayor. The remaining marchers rushed across. Along the way, they overpowered the bridge tender in case he had any ideas of changing his mind. Historian Pierce stated that Boone had the bridge put back into service because "he felt confident that his [security] arrangements were equal to any emergency." Perhaps, but so confident that he'd allow a few hundred additional armed and angry men to confront his police? A more practical explanation may have been suggested by the traffic

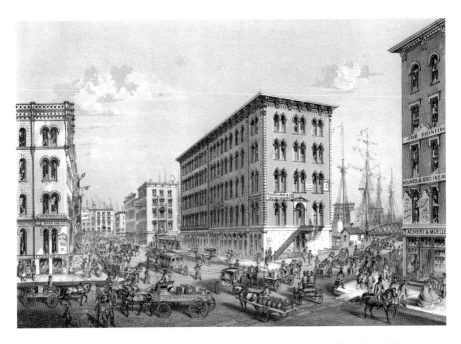

The intersection of Clark and South Water Streets, immediately south of the bridge, was normally congested, even without the presence of several hundred marchers. *Courtesy of Chicago Public Library, Special Collections and Preservation Division, CCW 4.32.*

THE GREAT CHICAGO BEER RIOT

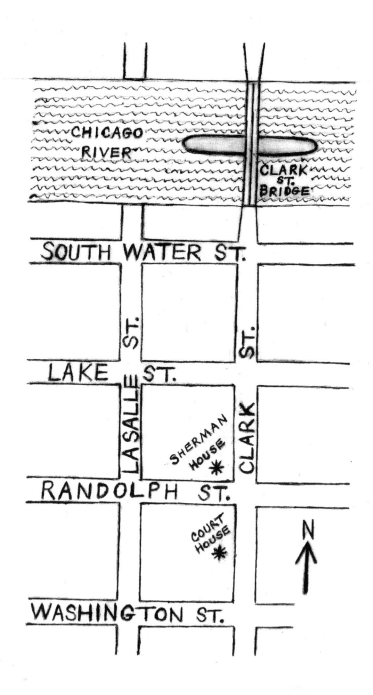

General location of the Lager Beer Riot. *Courtesy of Alex A. Burkholder.*

jam of wagons, carts, carriages and upset drivers backing up on both sides of the river.

This second mob that traveled the short distance from the bridge to the courthouse differed markedly from the earlier one, and not just because it was several times larger. These men had not come to stand in silent protest; they had blood in their collective eyes after four hours or so in which to refortify themselves with liquid courage. When they reached Randolph Street, they gave out a collective yell and then opened fire on the police who stood on the opposite corner. Onlookers who probably had expected a brawl at most understandably reacted with panic. In a flash, spectators were running in all directions. Some of the rioters shouted, "Pick out the stars. Shoot the police." They got off about twelve shots as the officers responded in kind. Before members of the mob had an opportunity to reload, a detachment of police rushed them and demanded that they surrender their weapons.

One of the attackers, a twenty-six-year-old shoemaker named Peter Martens, was armed with a double-barreled shotgun. Standing behind a hackney cab, Martens fired a blast that shattered the left arm of Officer George Hunt above the elbow and peppered his right side with buckshot. Doctors initially feared for the officer's life. Hunt survived, but his arm had to be amputated. The city later awarded him its bronze star and a payment of $3,000 on which the officer collected interest for the next twenty years. Mayor Boone acted as his financial agent. Hunt, married and the father of one, was retained on the police force and assigned to the comptroller's office, where he administered licenses and handled other duties for the next thirty-two years. His assailant, Martens, was fatally shot as he attempted to flee. He was brought down at the command of Sheriff James Andrews, the de facto Chicago police chief, who ordered a young man named Frazer standing at his side to open fire. It's not clear whether Frazer was a regular or special officer, but to Martens it made no difference.

Neither the police nor their adversaries proved to be very good shots. Martens became the only known fatality, although rumors persisted that other rioters had been killed and buried secretly. At least two bystanders were hit by stray rounds. Lawyer J.H. Kedzie was discussing a case in a second-floor office when a slug passed through a window and grazed his forehead. About the same time, a pedestrian identified as James Reese was crossing the street when a pellet pierced his hat, knocking it off while grazing his scalp. All told, nineteen people were injured.

The observer who wrote about the day years later said, "There were many broken heads, many persons roughly handled, more arrests" (sixty total).

The Great Chicago Beer Riot

Two of the broken heads belonged to policemen. Officer Nathan Weston was battling a rioter when two others attacked him from behind and inflicted critical injuries. A second policeman identified only as Officer Chubb also suffered severe head injuries. At one point, it appeared that the rioters would overpower the police detachment, but reinforcements arrived to drive the mob back across Randolph Street, where its members regrouped in front of lager saloons. The police pursued but met considerable resistance when they attempted to seize the weapons. Instead of surrendering his bludgeon, as ordered, one man struck the arresting officer on the head. The hard-headed cop managed to knock his attacker down, but as he was taking the man into custody, the policeman got knocked to the ground by a rioter who came up from behind. This incident led to a larger melee in which the rioters fought with renewed vigor. Most had to be pummeled into submission. Every man captured was armed either with a pistol, a knife or a club. After nearly an hour of combat, those who hadn't been taken into custody retreated back across the bridge.

Mayor Boone wasn't taking any chances. He had at his disposal no fewer than seven locally based volunteer militia companies, citizen soldiers loosely organized under the Sixtieth Regiment of the state militia. These were social clubs as much as military units, composed of men dressed in elegant uniforms who enjoyed parades and fancy dress balls more than close-order drill. The mayor called four of the outfits into service.

Late Saturday afternoon, Boone appeared on the courthouse steps, declared the city under martial law and appealed to all "good citizens" to disperse. A significant number of curiosity seekers had continued to mill about. Two mayoral deputies rode through the crowd on horseback repeating Boone's proclamation. Most followed orders, but a few had to be arrested. Back on Randolph Street, it was a different story. An excited, angry crowd had reassembled, shouting threats against the city government and vowing to free the prisoners. By now, the Chicago Light Guards, considered the crack militia unit in the northwestern United States, had moved into position in front of the courthouse. These men were ordered to clear Randolph, which they did, gradually and efficiently, opening a space between Clark and La Salle at the north end of the courthouse. The Light Guards were joined by another unit called the National Guards. The two militias, packing two thousand rounds of ball cartridge between them, fixed bayonets and staked out positions at the northeast and northwest approaches to Court House Square. Periodically, they dispatched patrols to make sure the adjacent streets remained quiet.

How Lager Struck a Blow for Liberty

Chicago could claim no fewer than seven semi-private militia companies in 1855, each dressed in its own style of elegant uniform. Mayor Boone called out four of the units to help quell the riot. *Courtesy of Matthew Owens*©.

The Great Chicago Beer Riot

Also called to arms was an artillery battery consisting of two guns under the command of banker Richard K. Swift, who called himself a brigadier general. History has not been kind to Dick Swift. The observer wrote mockingly that "he rode into the foreground, the guardian angel of the city." The mayor asked Swift to protect the courthouse with his artillery, but the banker/general protested that he couldn't cover four sides with two guns. "[T]he warlike mayor," historian Currey wrote, "drew a diagram showing him that by placing one gun at the corner of La Salle and Washington Streets and the other at the corner of Clark and Randolph Streets, he would be able to protect all the approaches to the square." Embellishing the anecdote, Andreas added that "[a]s soon as Swift became aware that the thing was practicable, he washed his hands of the whole affair, and left the guns in charge of his lieutenant, who was really an able officer, and would have thoroughly demonstrated the practicality of the mayor's views, had the mob given him an opportunity." In more concise language, he stood ready to mow them down.

For good measure, the city distributed handbills, in English and German over the mayor's signature, announcing the military occupation of the streets surrounding the courthouse and requesting everyone to stay away.

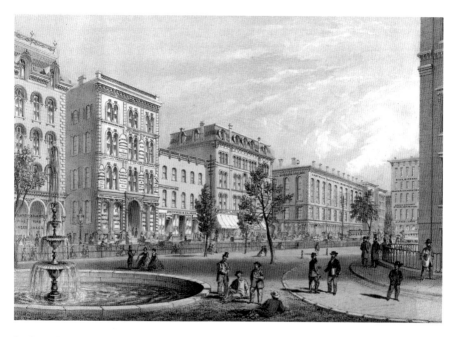

La Salle Street, looking west from Court House Square. *Courtesy of Chicago Public Library, Special Collections and Preservation Division, CCW 4.37.*

How Lager Struck a Blow for Liberty

The announcement didn't stop the rumor mill from buzzing again with predictions of another assault. Five thousand rioters were massing in Wright's Grove. Or perhaps they were gathering on Milwaukee Avenue, or maybe in the woods. "It was strange how many reliable informants knew just where this encampment was," the anonymous narrator remarked. The night passed quietly.

Chicagoans rose on Sunday morning after spending their first night ever under martial law. "All the generals, colonels, majors and captains attended church," the *Tribune* noted, "wearing swords, spurs, chapeaux and epaulettes." In a departure from earlier form, the paper mentioned a kind word about Catholics and the Irish. "[T]he Catholic churches were filled, as usual, and before the congregations were dismissed the priests exhorted them to go quietly and immediately home, and the exhortation was universally obeyed." The *Trib* said the Irish weren't part of any crowds, a conclusion not shared by historians. They were, however, prominent on the law and order side of the divide. The Montgomery Guards, known as a first-rate Irish militia company, was called to duty by Mayor Boone, who apparently decided to accept help wherever he could find it. The Montgomerys relieved the men of the Light Guards, who, judging from the sly implication of the all-seeing observer, had enjoyed themselves on sentry duty. During their encampment, he wrote, the Lights "could [have built] a barricade about them using empty champagne bottles," while members of other militias "ate crackers and cheese at their armories."

Two incidents marred an otherwise peaceful Sunday. En route to their assignment, the troops of the Montgomery Guards were led across the Clark Street Bridge by a small police detail commanded by Allan Pinkerton. The two groups were followed, in turn, by a sizeable crowd of armed Germans who had assembled in Washington Square, about three-fourths of a mile north of the river. The mob showered the police and troops with profanity-laced insults. When the law enforcers reached South Water Street, just across the river, the police formed a human corridor for the militia to pass through as they continued to the courthouse. The Germans tried to follow. If they had succeeded, the *Tribune* surmised, "the most serious consequences might have occurred, and another scene of bloodshed have taken place on the scene of the former battle." Instead, Pinkerton stepped forward, told his angry pursuers they could proceed no further and called on them as "good citizens" to disperse and go home. After some hesitation and grumbling, the Germans obeyed, with most going back across the bridge to the North Side. Pinkerton's resoluteness was somewhat reminiscent of Senator Douglas

The Great Chicago Beer Riot

facing down the mob at North Market Hall the previous year. Douglas was in town for the Saturday riot but supposedly had made up his mind to steer clear of the local liquor controversy. He was nowhere to be seen throughout the weekend.

In the second incident, Engine Company 2, a firefighting unit composed almost entirely of Germans, was returning from a blaze late Sunday afternoon when it attempted to cross Randolph Street at a point blockaded by the militia. Halted by the troops, the firemen simply left their engine in the street, removed the bell and headed up Clark Street, shouting as they went.

With the Montgomery Guards settled in for the night on the courthouse grounds, Mayor Boone and Sheriff Andrews issued a second, longer proclamation. This notice, again printed in English and German, urged everyone "friendly to law and order" to retire to their homes no later than 8:00 p.m. Anyone found to be armed and on the streets would be held as a rioter. The proclamation ended with an ominous note of caution: "In case the large bell on City Hall should be tolled, all citizens will regard it as a signal to leave the streets immediately, to avoid injury from the discharge of cannon." Everyone hunkered down for a night attack that many believed imminent, but nothing happened. The city hall bell never rang.

Monday dawned bright and clear. Soon after sunrise, a detachment of Light Guards arrived at the courthouse to relieve the Montgomerys. The streets and approaches to the building remained heavily protected. Inside, Justice Rucker was back on the bench. In sharp contrast to Saturday's commotion, the courtroom was sparsely filled with spectators, and decorum prevailed. Rucker freed all but fourteen arrested in the riot. They were bound over to the grand jury and subsequently indicted. All of the accused license violators were kept in jail. At noon, martial law was lifted.

The jury trial of the accused rioters began June 15 and lasted two weeks. It ended in the acquittal of all but two Irishmen named Farrell and Halleman, who were sentenced to one year in prison. The pair was granted a new trial less than a month later on the grounds of jury tampering by the supervising constable. They were never retried. It seemed "little less than a travesty of justice," Andreas concluded, "that in a sedition notoriously German the only victims should be two Irishmen, accidentally caught in the crowd, without any evidence of previous affiliation with the malcontents."

LAGER'S LEGACY

From the time Alderman La Rue began haranguing the Germans gathered in Ogden's Grove Saturday morning until the last stragglers came trudging back across the bridge late in the day, about seven hours had elapsed. Chicago remained under martial law for thirty-eight hours, from 10:00 p.m. Saturday until noon Monday. Yet the ramifications of the Lager Beer Riot would be felt far into the future. It would be a mistake to judge the events of April 21, 1855, as some aberration, a one-day occurrence. Life would not return to normal. After martial law was lifted, a new normal dawned. Chicago's first civil disturbance represented the culmination of forces already in play that would now take off in new directions. Serious prohibition crusades would lie dormant but, like Dracula minus the stake, would rise again.

The modern Chicago Police Department would be born. The Know-Nothing movement would begin a rapid descent toward extinction. Levi Boone's political career would end, but Stephen Douglas's would become reinvigorated. The nativist grip on city government would be broken. New political and ethnic alliances would form; immigrant voters would assert themselves. Scots and Irish would work together (for a while anyway), "like John Knox and the pope," to employ the *Tribune* analogy. Germans and Irish would also find common ground and help elect an Irish Protestant mayor. Chicago wouldn't elect its first Irish Catholic mayor, John Patrick Hopkins, until nearly forty years later. Hopkins became the first of many. Only one German has occupied the mayor's office—Fred Busse in the early twentieth

century—a disparity that has inspired the one-liner, "The Irish got city hall; the Germans got Turner Hall."

Battle lines between Democrats and Republicans would sharpen as the former strengthened their grip on immigrant, working-class, Catholic and anti-temperance voters, while the latter firmed up support among the native-born, the business class, Protestants and temperance adherents. There were exceptions, of course. Germans who were both immigrants and beer drinkers also tended to be staunchly abolitionist and, for that reason, defected to the Republicans in ever greater numbers. With the Democrats in disarray over the slavery issue, the new Republican Party would continue an ascent that would carry Abraham Lincoln to the White House.

Martial law had barely been lifted when Chicagoans, particularly the upper crust, turned out for a public meeting at South Market Hall to honor the lawmen who quelled the riot. Those in attendance realized that a better way was needed to deal with any future disturbances. They petitioned the common council for a larger, more effective police force, one that wouldn't have to rely on help from the militia for riot control. Along with the human toll, the riot had delivered a hit to the city treasury. The cost of deploying militia units, special deputies and covering medical bills amounted to $4,223.50. By comparison, the fines paid by those arrested totaled $420.00.

It often seems that a wakeup call in the form of some tragedy or dramatic upheaval is needed to focus attention on overdue remedial action that should have been obvious. Chicago was a rambunctious city of eighty thousand patrolled by eighty to ninety constables during the day and twenty-eight watchmen at night. All held second jobs to supplement their meager salaries. The chief law enforcement officer was the sheriff of Cook County. Participants in the April 24 meeting faced up to the obvious and appointed a committee to work with the Boone administration and create a real police department.

The results came within less than a week, but they didn't come easily. An ordinance creating a new police department squeaked by on a council vote of eight to seven. Every North Side alderman, whose wards contained substantial German populations, voted against the measure. To them, as well as their constituents, the police represented a repressive institution, a tool of the Puritan elite to keep working people from enjoying life as they saw fit. Memories were still fresh of policemen closing taverns on Sunday and arresting the proprietors. On any day of the week, a policeman was someone who was all too quick to arrest a man for having one too many, while more serious offenses went ignored. But like it or not, a new, upgraded

How Lager Struck a Blow for Liberty

Chicago police force had been born as a consequence of the beer riot. Some historians have maintained that the impetus for a better department began the previous year, after Senator Douglas was threatened by an angry mob. While that incident sparked talk of what ought to be done, no actual steps were taken.

To head the reorganized police department, Mayor Boone turned to an old hand and establishment favorite, Cyrus Parker Bradley, a Puritan blueblood who traced his roots back to early Massachusetts. Like Captain Nichols, Bradley was "a sworn member of the secret Know-Nothings Party," according to longtime Chicago alderman Edward Burke, co-author of the police history *End of Watch*. Bradley was a well-known figure, having served in a variety of elective and appointive positions. At various times, he had been fire marshal, deputy sheriff, city collector and tax collector for the Town of South Chicago. He wore two hats during the beer riot, that of police captain and captain of the Chicago Light Guards. He was considered a law enforcement professional, one of a new breed, who went on to put the department on a firmer footing. Nonetheless, he was an establishment defender through and through, someone who accepted the long-held notion that the Yankees who had reached Chicago first were forever destined to govern it and that the immigrant classes posed a continuing moral threat to the well-being of the city.

One of Bradley's early and significant accomplishments was the disbanding of Boone's cadre of special deputies. But that move didn't mean Chicago's ethnic populations could expect much different treatment. Officers under Bradley continued to arrest primarily working-class immigrants on nonviolent charges, usually public intoxication. During the first six months of the reorganization, Mitrani pointed out, the Irish, poorest of the large ethnic groups, accounted for two-thirds of more than 3,700 arrests, even though they composed only about one-fifth of the city's population. Just 11 percent of those arrested were identified as "Americans."

Of the innovations introduced by Bradley, one in particular stands out. Later in the nineteenth century and for years afterward, seeing a Chicago police officer in a blue uniform would be about as unusual as seeing blue water in Lake Michigan on a sunny summer day. Prior to the reorganization, however, the police wore street clothes with a small star affixed to their coat collars. If an officer wanted to conceal his identity, for whatever reason, good or bad, all he had to do was remove the star or hide it with his coat lapel. These were the stars that gun-toting beer rioters told one another to pick out. When a man donned a uniform, he no longer was a civilian constable but

rather a member of a paramilitary organization representing civil authority. The city kept pace with New York, Boston and Philadelphia, all of which also organized professional police departments in 1855. Police historian Mitrani concluded that "the [Chicago] police were transformed from an unorganized, undisciplined and poorly defined group of citizens into a well-ordered hierarchy organized along military lines and clearly differentiated from the rest of the population by their uniforms."

The Boone administration heeded most of the message delivered by the rioters. The city quietly backed away from Sunday closings and lowered the license fee hike from $300 to $100—still double the original amount, nevertheless. Temperance supporters consoled themselves with the knowledge that the statewide referendum was fast approaching and that all signs pointed to a comfortable victory. Clergymen, lay men and women and some politicians campaigned for passage. Maybe undecided voters were put off by the tactics of the Boone forces that produced the disorder. Perhaps there simply were more "wets" than "drys." Whatever the reason, few saw the backlash coming. When it hit, there were more long faces in temperance circles than free drinks in saloons as an election neared. Statewide, prohibition went down by a margin of fifty-four to forty-six. Chicago voters rejected the measure by nearly two to one—4,993 to 2,784. In Cook County, the negative vote was 5,182 to 3,807.

Illinois hardly stood alone. The Maine Law Alliance was in retreat across the nation. Legal challenges to restrictive or prohibitory laws were popping up and, in many instances, succeeding. Within a short span of time, defeats in New York, Massachusetts, Delaware, Indiana, Michigan, Minnesota and Nebraska left temperance forces reeling. Historian Jack S. Blocker Jr. posited that supporters became disillusioned and disaffected because the movement promised more than it could deliver and because it suffered from too much enforcement rather than too little. Instead of a more peaceable society, attempts to abolish or restrict drinking led to unrest, even violence, as they did in Philadelphia and later New York, where riots similar to Chicago's broke out.

Blocker wrote of an episode that happened in Portland, Maine, in which one of the chief architects of the restrictive law ironically helped cause its reversal. On the evening of June 2, 1855, two days before the Illinois referendum, second-term mayor Neal Dow, a fierce prohibitionist, found himself facing an angry mob as he stood on the ground floor of his city hall. Man against mob evoked memories of the encounters of Stephen Douglas, Levi Boone and Allan Pinkerton, but Dow's predicament was much more

unusual. The prohibitionist mayor was defending a stock of liquor that his adversaries were determined to seize. The legal technicalities were rather opaque, but essentially Dow had arranged for the purchase of a supply for Portland's liquor distribution agency, the only legal outlet for spirits intended for "non-beverage purposes." Under the letter of the law, the purchase should have been handled by a city agent. Since it wasn't, the law stated that it now became subject to seizure. A triviality, to be sure, but Dow's political enemies were determined to embarrass him. First, they filed a complaint with the police and then converged on city hall to ensure enforcement of the law. The police were joined by two dozen armed militiamen.

The confrontation became more intense when the police refused to confiscate the liquor. The mob grew more insistent, refusing to disperse even after the officers fired their revolvers. "[T]he room through which Dow peered was filled with smoke and the smell of gunpowder," Blocker related. "Sighting several members of the mob through the opposite door, Dow ordered the militiamen to level their rifles and take aim." Troopers fired three volleys, inside the building and out on the street. One man was killed and seven wounded. The shots, according to the author, "irretrievably [tarnished] the prohibitionist dream of an orderly world of upwardly mobile abstainers." The incident offered a glimpse of "a world unrecognizable… to millions of Americans who were drawn to the vision of peace and plenty that the enthusiastic prohibitionists such as Dow himself set before them."

Stephen A. Douglas could read the tea leaves as well as any politician. The implosion of the temperance movement gave him precisely the opportunity he'd been seeking to regain momentum that he hoped would carry him to the 1856 Democratic presidential nomination. The first step toward that goal was the Chicago municipal election in March of that year. Bessie Pierce is partly correct when she wrote that the local races turned largely on national issues, primarily the festering question of slavery's expansion into Kansas and Nebraska. Douglas wanted "a vote which would appear a ratification of the Kansas-Nebraska Act by this important group of his constituency." That certainly was the case, but Douglas and his strategists also factored in the backlash created by the beer riot and the disrespect felt by the Germans, Irish and other immigrant groups. So, they wrapped slavery and liquor into one electoral package. Douglas and his wing of the party stood for popular sovereignty on slavery and personal liberty on liquor—if Kansans wanted a slave state, so be it; if Chicagoans wanted a drink, so be it. As Hillary Clinton would remark in so many words years later, a vote for one is a vote for both. Anti-Nebraska voters, liberal Germans in particular, might well overlook the

national issue to protect their right to drink beer on Sunday. "Thus, Douglas could purge his anti-Nebraska opponents in a contest his party was bound to win on the liquor issue," Robin Einhorn concluded.

To sell the package to voters, the Douglas camp put together a well-organized, machine-style campaign the likes of which the city had never seen. Previous municipal elections had been nonpartisan affairs. Candidates may have been Democrats or Whigs or whatever, but they ran without official party backing. Those who favored this arrangement believed it kept corrupt influences out of the picture. Nonsense, the Douglas forces said. Chicago was a solidly Democratic town, and they intended to field a Democratic ticket—large D.

They began by organizing at the grassroots, forming clubs of Douglas supporters in each of the city's fifteen wards. Next they called a party convention and nominated a full slate of candidates headed by Thomas Dyer, a hard-drinking Irish non-Catholic who had made a lot of money as a grain dealer and in other business ventures. Another wealthy businessman, and onetime mayor, Francis Sherman, became the standard bearer of a blue-ribbon committee of 250. The list of VIPs included well-known names such as Ogden, Wentworth and Georg Schneider, Democrats opposed to the extension of slavery. Although Pierce maintained that the election was watched throughout the state "as a barometer of sentiment for or against the Little Giant," Douglas's position on slavery became overshadowed by two issues of more parochial interest: temperance and Know-Nothingism. That was just fine with Douglas.

Levi Boone had wisely chosen not to seek reelection, but his legacy of antipathy toward immigrants and Catholics, along with his disastrous temperance measures, remained fresh. Fairly or not, the Dyer campaign characterized its opponents as prohibition supporters who also were hostile to foreigners. To underscore its opinion of the Maine Law, it established election headquarters at Cook's Saloon.

Each camp accused the other's mayoral candidate of having Know-Nothing credentials. The *Tribune*, an all-out Sherman supporter, claimed that Dyer once applied for membership in a Know-Nothing lodge but got turned down. The paper further charged that the regular Democratic candidate enjoyed the support of Know-Nothings who attended the party's county convention and that he'd once been strongly opposed to the Kansas-Nebraska Act but changed his position when Douglas tapped him to run for mayor. Dyer didn't refute any of the accusations. Sherman, on the other hand, stood accused on several occasions of being a Know-Nothing by the

How Lager Struck a Blow for Liberty

Democratic-leaning *Times*. The candidate published a letter flatly denying any connection and obtained a statement from a Know-Nothing spokesman stating as much. Even the *Tribune* was forced to concede that each of the six candidates running below Sherman on the American Party ticket was a Know-Nothing, nominated, the paper alleged, at a clandestine meeting. The *Trib* adamantly refused to endorse anyone, regardless of office or party, except Sherman.

Violence. Intimidation. Rowdyism. Bribery. Vandalism. The 1856 mayor election eclipsed all predecessors. Street fights broke out across the city. Even respected citizens became involved. On Clark Street, outside the Illinois State Bank, United States District Attorney Thomas Hoyne and Charles L. Wilson, editor of the *Chicago Daily Journal*, duked it out. Wilson "pummeled [Hoyne] pretty effectively," in the words of one account, knocking him through the bank's front window.

The rivalry showed an amusing side as well. On the night of a great Democratic torchlight parade, some of the participants found themselves running out of fuel for the lamps they carried. One at a time, they dashed into a drugstore located along the parade route to fill up. The clerk, an ardent Republican, took each lamp into the back room, filled it with water and cautioned the customer not to light up in the store. A grateful marcher paid a dime and hurried to rejoin the parade, only to find that his lamp wouldn't light. The following week, when the Sherman forces held a similar march, the clerk filled their lamps with oil but charged nothing. He told the customers that their Democratic friends had paid in advance.

Election day, March 4, coincided with the city's nineteenth birthday. Some of the celebrants were roving bands of "head-knockers" who descended on polling places but failed to deter a huge turnout. Germans and Irish who had been caught napping a year earlier came out in squadrons to contribute to an overwhelming Dyer victory. Douglas spokesmen tried to spin the results as a vindication of the senator's position on slavery extension, but the outcome clearly marked a repudiation of Boone's policies. No one had talked about Kansas or slavery. Even the most zealous abolitionist voters responded to the regular Democrats' campaign against Know-Nothingism. The *Tribune* reported that German Catholics and German Lutherans, Scots and Irishmen, set aside their long-held differences and worked together as if it were a matter of life and death. In a word, the paper concluded, the results boiled down to organization; the Democrats had it, their opponents didn't.

The *Democrat*, as its name indicated, was a Democratic paper with a capital *D*, but owner John Wentworth was a mortal enemy of the Little Giant. The

THE GREAT CHICAGO BEER RIOT

Democrat charged that Douglas spent $50,000 on the campaign, much of it in saloons where votes could be bought. That accusation dovetailed with cries of fraud from the Sherman camp that claimed that the 9,000 total votes cast outnumbered eligible voters by 1,500. The common council, still controlled by Mayor Boone's supporters, appointed a committee to investigate. Among a variety of alleged irregularities, the panel's report found that teams had been sent to Bridgeport and other locations outside the city limits to bring in illegal voters, that additional voters had been imported from four nearby counties, that fees for naturalization papers had been paid in return for immigrant votes and that bribes had been paid to aldermen for redistribution among election judges. Lack of a voter registration law made shenanigans relatively easy to pull off. The council committee recommended adoption of such a law. The *Tribune* urged the losers to regroup under the banner of the fledgling Republican Party.

Douglas was riding high after Dyer's victory but was unable to gain much political capital from it as he sought the presidential nomination. The senator went to the 1856 national convention in Cincinnati with hopes ascendant but couldn't break through a crowded field of candidates. He withdrew his candidacy before the balloting started, supposedly after receiving assurances from power brokers of strong support four years later. The nomination went to James Buchanan, who captured the presidency in November.

Befitting a triumph by an anti-temperance candidate, Thomas Dyer's inaugural parade amounted to a rowdy spectacle that rollicked through the clogged, dusty streets of the business district. The *Tribune* labeled the celebration "the big drunk": "All day the city swarmed with riff-raff…They filled the Dyer carriages. They carried Dyer flags. They strained their throats in hurrahs for Dyer. The groceries ran whiskey for Dyer's honor." Many onlookers were scandalized to see an assortment of prostitutes and their pimps joining the parade. One version noted that they walked, and another claimed they rode in carriages.

In his inaugural remarks, Mayor Dyer departed from the tradition of successful candidates at all levels. Instead of extending an olive branch to the opposition and offering to work together for the betterment of all, he lashed out at "renegade Democrats." He identified them as unsuccessful office-seekers who had worked to defeat him by making "ill-mannered, ill-tempered and ridiculous appeals…I was a Know Nothing one day, and the next was said to have been black-balled [by the Know-Nothings]. I was represented as the candidate of the saloons on the one hand, and as having voted for prohibition…on the other."

How Lager Struck a Blow for Liberty

The new mayor left no doubt that he intended to reward his friends (i.e., Douglas Democrats) and, by implication, punish his enemies. To the latter end, he forced Cyrus Bradley into retirement, abolished the title of chief of police and replaced him with City Marshal James Donnelley, the man Boone had dumped in favor of Bradley. A number of officers loyal to Bradley, men whose competence was never questioned, resigned in protest, which was fine with Dyer. He fired most of those who didn't quit. Until 1861, the police department served as a mayor's private army. He held the authority to hire and fire at will, assign duties and determine the degree of enforcement for each law. New applicants, mostly young Irishmen with no law enforcement experience, lined up to fill the vacated positions. Thus began an Irish influence in the department that would last for generations. A number of the new recruits were hired because they had worked in Dyer's election campaign. Following his dismissal, Bradley organized one of the city's first private security forces. Allan Pinkerton started another. Generally considered more efficient than the city police, the Bradleys and Pinkertons developed an extensive clientele among the city's business establishments. After John Wentworth succeeded Dyer as mayor, he offered the far-fetched theory that his arch-foe Bradley, with Pinkerton's help, was enticing low-level criminals to come to Chicago so they could arrest them, burnish their agencies' reputations and make the city police look bad by comparison.

Toward the end of 1856 and in early 1857, Chicago didn't need to import lawbreakers; the city was overrun with them. Financial depression had descended on the nation once again, and few places felt it more keenly than Chicago. The streets were thronged with idle men. They filled the railroad terminals and almshouses. Crime increased alarmingly. Nighttime burglaries became commonplace, as did robberies, which now extended to residential areas. Dyer expanded the police force by more than twenty men but to no avail. Public confidence in the department—and mayor—hit bottom. He opted not to run again.

A rising tide, as the saying goes, lifts all boats. One of the boats lifted by the rising tide of Republicanism contained a very large passenger, Long John Wentworth. The former six-term congressman, a slavery opponent, had been growing increasingly disenchanted with the Democrats' embrace of the Kansas-Nebraska Act. So, when the Republicans came courting him as a mayoral candidate, Wentworth said yes and switched parties. The big man was just the tonic the new movement needed. His personal popularity extended across political and class divisions, his well-known opposition to temperance scored points with the ethnic communities and his stance

against Kansas-Nebraska put him right in step with a party whose focus was primarily national and whose key issue was opposition to slavery.

The election of March 4, 1857, by coincidence another municipal birthday, pitted Wentworth against an unknown Democratic bank cashier named Benjamin Carver. Attracted as they may have been by Long John's feelings about temperance, the Irish stayed in the Democratic column. The Germans, on the other hand, were tilting ever more Republican to reflect their antislavery convictions. Now they had a candidate who was both strongly antislavery and anti-temperance. Thus, a schism developed between two nationalities that had contributed to Tom Dyer's landslide. Wentworth had never concealed his opinion of the Irish. At one campaign stop, he shared the dais with Lincoln. The future president's thoughts can only be imagined as Long John stressed the need to rid the police department of "Hibernians" and replace them with native-born Americans.

The election proved even more violent that its predecessor. Lame duck Dyer did nothing to ease an already volatile situation by allowing the saloons to remain open on election day. Street fights and riots broke out across town resulting in a number of injuries, some severe. The most serious incident began shortly before noon when an estimated 150 South Side Irish, backing Carver, decided to visit North Side polling places where the Germans were turning out for Wentworth. The inebriated South Siders came armed with clubs, knives and rocks as the police reportedly looked the other way. When a young German voter named Charles Seifert left his polling place, he was set upon and beaten to death. The *Tribune* blamed the Irish. Much less plausibly, the Democratic-leaning *Times* saw a plot by Wentworth supporters to discredit Mayor Dyer. No one was arrested.

Wentworth defeated Carver by a margin of almost three to two. In his inaugural speech, the new mayor took note of Seifert's death and said that it demonstrated the need for a "more energetic" police force. Following the lead of his predecessors, he promptly sacked many of those hired by Dyer and replaced them with men of his own choosing. He also added a new wrinkle. A police applicant would have to submit the names of two businessmen who would vouch for his good character. Additionally, Wentworth proposed a residency requirement. Not only would officers be required to live in the city, but they also would have to be apportioned throughout every neighborhood. "Every family will know that there is, within a convenient distance, a house of respectable occupants" where neighbors could lodge complaints of illegal activity. Nothing came of these proposed restrictions. The broader residency requirement wouldn't be adopted until years later and remains in effect today

after surviving court challenges. Officers may live in any neighborhood as long as it's within the city limits.

Convinced that Cyrus Bradley and his private security force were trying to show up his city police, Wentworth decided to stage a grandstand play that would also aid the business interests of his friend William Ogden. "There are as many versions of the story as there are persons who tell it," admitted early police historian John J. Flinn. On the morning of April 20, 1857, about five weeks into his term, Long John positioned himself at the head of a thirty-man police column. Together they marched on a notorious vice district known as the Sands, which was located just north of the river and inhabited by prostitutes, pimps, gamblers, thieves and sundry other characters. "A large number of persons, mostly strangers in the city, have been enticed there and robbed, and there is but little doubt that a number of murders have been committed," wrote Flinn.

The district's tawdry reputation meant nothing to sharp-eyed real estate speculators who had their eyes on the land beneath the brothels and gambling casinos. In fact, its very seediness enhanced the Sands as a target for some upright citizens to eradicate and make way for the city's legitimate business expansion. One of the speculators was Ogden, who bought an interest in a number of buildings and had his agents tell the occupants to clear out. The inhabitants refused, in spite of a threat that the buildings would be torn down. This is when Wentworth became involved. Accompanied by a land agent and deputy sheriff armed with eviction notices, the mayor and his police moved in. But first, Wentworth reportedly employed a ruse to decrease the number of potentially troublesome inhabitants he and his men might have to face. He caused word to be circulated that a cock fight—other versions say a dog fight or horse race—for large stakes would be staged that day, outside the city limits. The stratagem succeeded, although Wentworth never confirmed or denied its use.

Denizens of the Sands were given time to move their furniture and other belongings into the street before the mayor and his crew attacked nine buildings with hooks and chains. A crowd of several thousand onlookers cheered them on. One after another, the flimsy structures toppled. Later in the day, six surviving wooden buildings burned to the ground. Since three caught fire simultaneously, arson seemed obvious. The fires were believed to be the handiwork of vice operators intent on defying their new landlord, former mayor Ogden. That night, three prostitutes who had been driven out found shelter in an abandoned hut. They were raped by persons unknown. No arrests were made.

The Great Chicago Beer Riot

In 1857, Mayor Wentworth led a column of police into a notorious vice district called the Sands and demolished it. Some said that Wentworth coveted the land for his real estate speculator friends. *Courtesy of the Chicago Public Library.*

Wentworth added to his folk hero credentials in the eyes of many, especially those in the business community, but his raid did little to eradicate vice. Its operators simply moved on to other parts of town, and the Sands itself rose from the rubble during the Civil War to again offer games of chance and close encounters of the amorous kind.

Overshadowing all else in 1857 was the depression, whose pain was compounded by one of the harshest winters ever faced by the young community. Hardship, poverty and crime lurked everywhere. Wentworth decided not to seek reelection in 1858, but the Republicans held the mayor's office by electing John Haines, a former flour miller and multiple-term alderman. Haines served two competent though unspectacular one-year terms, while Wentworth took an extended sabbatical in New York. Some said that Long John was anxious to avoid a grand jury that was looking into the disappearance of city funds intended for use in an undercover investigation of the red-light districts. After the matter blew over, Wentworth returned to claim the chair that Haines had kept warm for him.

A lot had changed in two years, as it usually does in politics. Lincoln and Douglas had held their historic series of debates during the summer

of 1858. The legislature went Democratic in the fall and consequently reelected the Little Giant to another term in the U.S. Senate. Both men set their sights on a rematch for larger stakes: the 1860 presidential race.

Upon his return, Wentworth became involved in Republican factional fights "so fierce that many observers suspected [he] would bolt back to the Democratic Party, but he did not," Sam Mitrani wrote. "As a former Democrat strongly opposed to the extension of slavery, Wentworth represented a crucial piece of the Republican coalition, but he was completely out of step with the modernizing Whig forces within the party." He had to struggle to recapture the mayoral nomination but had little trouble beating the Democratic candidate, former mayor Walter Gurnee. The triumph solidified Wentworth's standing in the party in one additional way. He was now mayor of the host city for his party's 1860 presidential nominating convention.

The conclave was held in a temporary two-story wooden structure called the Wigwam, which was thrown together in a month's time on the southeast corner of Lake and Market Streets (later Wacker Drive). Funds to build the Wigwam and cover other expenses were raised by Chicago's business community. Wentworth found a novel method to help fund the city's share: he cut the police force in half. A small price to pay, he no doubt rationalized. With the nation on the brink of civil war, Long John considered his role in Lincoln's nomination the crowning achievement of his career in public service. Lincoln's victory in November also provided him with a measure of revenge. His old enemy Douglas ran second in the four-way race.

Stephen Douglas's greatest fear, that the election of Lincoln would cause the southern states to secede from the Union and provoke civil war, came to pass on April 13, 1861, when Confederate forces fired on Fort Sumter. After that, there never was any question how the Little Giant would react. He put patriotism above party and rallied behind Lincoln and the Union cause. The president, it was said, could claim no stronger ally than his old rival from Illinois. Soon after the conflict started, the senator returned home from Washington to rouse his adherents to the cause. The native-born population, the old Yankee stock, needed no convincing; they already were in the fold and wouldn't have paid much heed to Douglas no matter what he said. But what about one of his core constituencies, Chicago's fifty thousand foreign-born? Where would they stand? Only yesterday, it seemed, the party that was now calling them to arms wanted to relegate them to second-class citizenship. These were the folks who had told them they were unfit to hold public office or become police officers, the people they had fought for the privilege of

drinking beer on Sunday or operating a small business without going broke trying to pay for the license. Their answer wasn't long in coming.

"From the North Side came a reassuring answer," historian Lloyd Lewis recorded. "The Germans, the Jews, themselves German, the Scandinavians and the French overlooked past wrongs and for the sake of the anti-slavery cause supported the union." Within six months, an estimated six thousand Germans from Illinois joined the Union army, and they kept on enlisting through the late stages of the war. The Thirteenth Cavalry Regiment, the German Guides, formed in Chicago in December 1861. The Chicago Jaegers, the Turner Cadets and the Lincoln Rifles preceded them. German American communities Downstate were not to be outdone. Frederick Hecker, the 1848 revolutionary firebrand who became a Belleville area farmer, enlisted as a private in a Missouri regiment but ended up organizing the Twenty-fourth Illinois Infantry. The outfit became known as the Hecker Regiment. Another Forty-Eighter from that part of the state, Augustus Mersy, organized a company and became a lieutenant colonel. Germans from Springfield, Ottawa and additional locales joined up. Some Downstaters, like Hecker, were so eager to take up the fight that they enlisted in Missouri regiments when counterpart units in Illinois were slow to organize.

And what of the Irish? None of the immigrant groups had experienced more abuse at the hands of the Yankee establishment or its organ, the *Chicago Tribune*, now the flagship Midwest newspaper of the Republican Party. The suspicion existed that Irish laborers would look beyond the war and balk at fighting to free slaves who might compete against them in the job market. The question of Irish sympathies was put to rest on the evening of April 20, 1861, when Chicago's Irish flocked to a pro-war rally at North Market Hall. They had been urged by a committee of prominent countrymen to "rally for the honor of the Old Land…Rally! For the defense of the New" by forming a regiment of volunteers. Within two hours, 325 men had signed up. They became members of the Twenty-third Illinois, the fabled Irish Brigade under the command of Colonel James A. Mulligan. The Nineteenth Infantry, the Irish Legion, was organized in Chicago the following year. Irish Americans from Springfield, Rockford and Galena formed their own companies.

Overall, Chicago enlisted 3,500 men of all backgrounds during the first three weeks of the war. Much of the credit for successful recruitment throughout Illinois belonged to Douglas, who conducted a feverish speaking campaign that took him the length of the state. "No one can be a true Democrat without being a patriot," he assured his political followers. Chicago Democrats didn't require much convincing, but their Downstate brethren

presented a tougher challenge. Residents whose forbearers had come from Virginia were turning out at mass meetings to profess their loyalty to the South. One county proposed that it divide itself between the Union and the Confederacy. Before his subsequent conversion, Congressman John A. Logan delivered a speech in which he compared the breakaway Southerners to the Revolutionary War heroes of 1776.

Undeterred, Douglas "spoke as he had never spoken before," Lewis related, "arguing, pleading for loyalty. Illinois, for all that had voted him down four months earlier, loved him better than any man of that day, and under his spell, those who had once been Kentuckians, Virginians or North Carolinians stood for the Union." But the grueling pace, preceded by years of hard living, was taking its toll. Douglas contracted typhoid fever. He returned to Chicago, where he died on June 3 at his beloved Tremont House. He was only forty-eight. His dream of building an estate overlooking the lake, south of the city, was never realized. Only a small cottage was constructed there during his lifetime. His wife, Adele Cutts, survived him by thirty-eight years. Their only child, a daughter, had died in infancy.

Born a southerner but a member in good standing of Chicago's eastern establishment, Levi Boone remained an enigma. At the start of the war, the slavery proponent declared himself a faithful Union man and saw his son join the army. He became the first man in Chicago to offer a bounty for enlistments. He further promised to contribute a city lot or a forty-acre farm to the widow of the first Chicago volunteer to die in action. Boone may have felt a twinge of irony, but he didn't hesitate to make good on his pledge when the widow of an Irish Brigade member stepped forward to accept the offer. His loyalty was severely challenged a year later.

In August 1862, Boone was arrested and confined to a military stockade on a charge aiding the escape of a Confederate prisoner of war. As with many an anecdote of the period, the details vary according to the narrator. The following represents a consensus.

Boone was one of several physicians volunteering at Camp Douglas, a prison for Confederate POWs on the site where the late senator had planned to build his estate and which was now named for him. (Years later, Douglas was reinterred at the former camp location, which today holds a small state park named in his honor. A ten-foot statue stands atop a forty-six-foot column overlooking South Lake Shore Drive and facing east, toward Washington.) Camp Douglas was notorious for its inhumane conditions. Overcrowding, filth, unsanitary practices, disease and death ran rampant. There wasn't a lot Boone and his humanitarian colleagues

The Great Chicago Beer Riot

Overview of the nightmarish Camp Douglas on the near south lakefront, where nine thousand Confederate prisoners of war were held died by the thousands under inhumane conditions. *Courtesy of the Chicago Public Library.*

could do to alleviate the suffering among nine thousand inmates confined to a reservation designed for thousands fewer. One of the ways the volunteers made the captives' ordeal a little easier was to help them obtain a few basic necessities. Friends or family members could leave modest sums with Boone or the others with the understanding that the money would be used to benefit their loved ones.

The mother of one young POW named Tom Green came to Chicago with the intention of subverting the arrangement to help her son escape. Apparently, the plot called for Mrs. Green to somehow get money directly into Tom's hands so he could bribe his way out. Before she left town, Mrs. Green left fifty dollars with Dr. Boone and asked him to pay for any items her son might require. Boone said that he put the cash in an envelope, marked it "Tom Green's money" and locked the envelope in his safe. Then the doctor was called out of town. Green, meanwhile, learned of the money in the safe and enlisted a medical student filling in for Boone to help him get the cash. The student, who presumably had the key or combination to the safe, agreed. After pocketing thirty dollars of the total, he let Green escape. The young POW was barely over the fence when he was apprehended, betrayed by his friend the medical student.

How Lager Struck a Blow for Liberty

When routine interrogation failed, Green's captors supposedly strung him up by his thumbs. All he knew, he claimed, was that the money came from Dr. Boone. That was enough for the interrogators. When he returned to Chicago, the doctor was arrested and charged with conspiracy to aid in the escape of prisoners of war. Without offering evidence or naming sources, the *Tribune* put a pejorative spin on the events: "Mr. Boone has for a long time been acting as an agent, receiving large sums for the prisoners from the Southern Confederacy." Accusing Boone of "giving aid and comfort to traitors," the paper noted that the doctor more than once had declared that the Southern POWs "are abused and treated shamefully." If Boone had used those words, which he probably did, he was merely stating an incontrovertible fact.

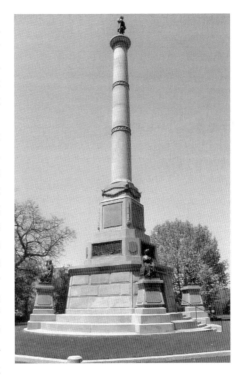

A statue of Stephen Douglas today rises above the former POW camp named in his honor. The site includes the senator's tomb and a small state park. *Photo by John F. Hogan.*

Following a brief incarceration, Boone was released "on parole." He still was technically "on parole" on January 24, 1882, when he died at seventy-three. Unconfirmed accounts note that in his later years, he deeply regretted his actions that led to the Lager Beer Riot of 1855.

BIBLIOGRAPHY

Andreas, A.T. *History of Chicago*. Chicago: self-published, 1884.
Baugher, Shirley. *Hidden History of Old Town*. Charleston, SC: The History Press, 2011.
Beatty, William K. "When Cholera Scourged Chicago." *Chicago History Magazine* (Spring 1982).
Belden, David A. *Illinois and Michigan Canal*. Charleston, SC: Arcadia Publishing, 2012.
Blocker, Jack S., Jr. *American Temperance Movements: Cycles of Reform*. Boston: Twayne Publishers, 1989.
Burke, Edward M. *End of Watch: Chicago Police Killed in the Line of Duty, 1853–2006*. Chicago: Chicago Books Press, 2007.
Capers, Gerald M. *Stephen A. Douglas: Defender of the Union*. Boston: Little, Brown and Company, 1959.
Chicago Democrat.
Chicago Times.
Chicago Tribune.
Cronin, Mike. *A History of Ireland*. London: Palgrave, 2001.
Currey, J. Seymour. *Chicago: Its History and Its Builders*. Chicago: S.J. Clare Publishing Company, 1912.
Dankers, Ulrich. *Early History of Chicago*. River Forest, IL: Early Chicago Inc., 2000.
Davis, Stephen M. "Of the Class Dominated Princely: The Tremont House Hotel." *Chicago History Magazine* (Spring 1982).
Einhorn, Robin L. *Property Rules: Political Economy in Chicago, 1833–1872*. Chicago: University of Chicago Press, 1991.
Fehrenbacher, Don E. *Chicago Giant: A Biography of "Long John" Wentworth*. Madison, WI: American History Research Center, 1957.
Flinn, John J. *History of the Chicago Police*. Chicago: Police Book Fund, 1887.
Gale, Edwin O. *Reminiscences of Early Chicago and Vicinity*. Chicago: Fleming H. Revell Company, 1902.
Gribben, Arthur, ed. *The Great Famine and the Irish Diaspora in America*. Amherst: University of Massachusetts Press, 1999.

Bibliography

Grossman, James R., Ann Durkin Keating and Janice L. Reiff, eds. *The Encyclopedia of Chicago*. Chicago: University of Chicago Press, 2004.

Harpster, Jack. *A Biography of William B. Ogden*. Carbondale: Southern Illinois University Press, 2009.

Hofmeister, Rudolph A. *The Germans of Chicago*. Champaign, IL: Stipes Publishing Company, 1976.

Keil, Hartmut, and John B. Jentz, eds. *German Workers in Industrial Chicago, 1850–1910: A Comparative Perspective*. De Kalb: Northern Illinois University Press, 1983.

Kelly, John. *The Graves Are Walking: The Great Famine and the Saga of the Irish People*. New York: Henry Holt and Company, 2012.

Lewis, Lloyd. *Chicago: The History of Its Reputation*. New York: Harcourt, Brace and Company, 1929.

Lindberg, Richard C. *To Serve and Collect: Politics and Police Corruption from the Lager Beer Riot to the Summerdale Scandal*. New York: Praeger, 1991.

Mann, Golo. *History of Germany Since 1789*. New York: Praeger, 1968.

Marohn, Richard C. "The Arming of the Chicago Police in the Nineteenth Century." *Chicago History Magazine* (Spring 1982).

Mayer, Harold M., and Richard C. Wade. *Chicago: Growth of a Metropolis*. Chicago: University of Chicago Press, 1969.

McBriarty, Patrick T. *Chicago River Bridges*. Chicago: self-published, 2013.

McCaffrey, Lawrence J., Ellen Skerrett, Michael F. Funchion and Charles Fanning. *The Irish in Chicago*. Urbana: University of Illinois Press, 1987.

Merriner, James L. *Grafters and Goo Goos: Corruption and Reform in Chicago, 1833–2003*. Carbondale: Southern Illinois University Press, 2004.

Miller, Donald C. *City of the Century: The Epic of Chicago and the Making of America*. New York: Simon & Schuster, 1996.

Mitrani, Sam. *The Rise of the Chicago Police Department: Class and Conflict, 1850–1894*. Urbana: University of Illinois Press, 2013.

Pacyga, Dominic A. *Chicago: A Biography*. Chicago: University of Chicago Press, 2009.

Pierce, Bessie Louise. *A History of Chicago*. Vol. 2, *From Town to City, 1848–1871*. New York: Alfred A. Knopf, 1940.

Sheahan, James W. *The Life of Stephen A. Douglas*. New York: Harper & Brothers, Publishers, 1860.

Skilnik, Bob. *The History of Beer and Brewing in Chicago, 1833–1978*. Chicago: Pogo Press, 1999.

Smith, Gregg. *Beer in America the Early Years, 1587–1840: Beer's Role in the Settling of America and the Birth of a Nation*. Boulder, CO: Brewers Publications, 1998.

Tiwana, Shah, Ellen O'Brien and Lyle Benedict, eds. *Inaugural Addresses of the Mayors of Chicago, 1840–1999*. Municipal Reference Collection, Chicago Public Library, 1999.

Wells, Damon. *Stephen Douglas: The Last Years, 1857–1861*. Austin: University of Texas Press, 1971.

Wittke, Carl. *Refugees of Revolution: The German Forty-Eighters in America*. Philadelphia: University of Pennsylvania Press, 1952.

Zucker, A.E., ed. *The Forty-Eighters: Political Refugees of the German Revolution*. New York: Columbia University Press, 1950.

INDEX

A

Andreas, A.T. 30
Andrews, James, Sheriff 81
Anthony, Susan B. 16
anti-Catholicism 28, 59, 68

B

Baugher, Shirley 48
Black Laws 39
Blocker, Jack S., Jr. 90
Boone, Dr. Levi Day 32
Bradley, Cyrus Parker 89
Bridgeport 27, 94
Bross, William 62
Burke, Alderman Edward 89
Busse, Fred 87

C

Camp Douglas 101
Capers, Gerald M. 44
Chicago Board of Trade 39
Chicago Daily Journal 93
Chicago Daily Tribune 68
Chicago Democrat 32, 45
Chicago Times 58
Chicago Tribune 28, 34, 52, 72, 100
Chicago Union Stock Yards 39
cholera epidemic 30
Clark Street bridge 64
coffin ships 21
Cole, Arthur Charles 65
Court House Square 75, 78, 82
Cronin, Mike 20
Currey, J. Seymour 53
Cutts, Adele 16, 101

D

Democratic Press 62, 64
Der Westen 24, 49
Diversey, Michael 47
Douglass, Frederick 18, 19, 20, 55, 72
Douglas, Stephen Arnold, Senator 16, 38, 44, 45, 53, 57, 58, 59, 60, 61, 62, 63, 64, 65, 67
Dow, Neal, Mayor 90
Dyer, Thomas 92, 94

E

Egan, Dr. William Bradshaw 43
1820 Missouri Compromise 58

Index

Einhorn, Robin L. 27
Emerson, Ralph Waldo 46

F

First Baptist Church 34
Flinn, John J. 97
Forty-Eighters, the 12, 13
Fugitive Slave Law of 1850 53, 55, 57, 61

G

Galena, Illinois 36
German Revolution of 1848–49 12
German Turners 60
Great Fire of 1871 23, 41
Greeley, Horace 36
Gurnee, Walter, Mayor 38, 99

H

Harpster, Jack 74
Hass, Wilhelm 24
Hecker, Frederich 12, 100
Hibernian Society 60
Hopkins, John Patrick, Mayor 87
Huck, John A. 47
Hunt, George, Officer 81

I

Illinois and Michigan Canal 26, 30
Illinois Central (IC) 37, 38
Illinois Staatszeitung 24
Irish Brigade 100
Irish Famine 11, 20, 21, 26, 27, 30

J

Jones, John 53, 55
Jones, Mary Richardson 55

K

Kansas-Nebraska Act 57, 58, 61, 63, 65, 67, 91, 92, 95
Kilgubbin 27
Klugel's Lager Beer Saloon 48

Know-Nothing Party 59
Know-Nothings 59, 60, 61, 65, 67, 68, 69, 92, 93, 94

L

La Rue, Stephen D. 72
Lauer, Kaspar 24
Lill Brewery 56
Lincoln, Abraham 36, 88

M

Maine Law 50, 51, 52, 65, 70, 90, 92
Mann, Golo 11, 12, 13
Martens, Peter 81
Mayer, Harold M. 29
McCormick Reaper Works 39
Medill, Joseph 68
Merriner, James L. 71
militia companies 82
Miller, Donald L. 36
Miller, Kerby A. 20
Milliken, Isaac 52, 68, 69
Missouri Compromise 62, 63
Mitchel, John 20
Mitrani, Sam 49, 56, 99
Mott, Lucretia 15
Mulligan, James A., Colonel 100

N

New York Tribune 36
Nichols, Luther, Captain 78
North Market Hall 61, 72, 86, 100

O

Ogden's Grove 48, 49, 75, 87
Ogden, William Butler 35

P

Pierce, Bessie Louise 23, 37
Pinkerton, Allan 55, 85, 90, 95
Pioneer, the 36, 37
Pullman, George M. 41

Index

Q
Quinn, James, Constable 24

R
Reid, Martha 57
River and Harbor Convention 36

S
Sabbath Convention 52
Sands, the 97
Sauter, Charles 24
Scandinavian Union 60
Schneider, Georg 24, 58, 92
Schneider, John 47
Schurz, Carl 22, 23, 41
Seifert, Charles 96
Seneca Falls, New York 15
Sheahan, James 59, 60
Skilnik, Bob 47
South Market Hall 51, 88
Stanton, Elizabeth Cady 15, 16, 19, 51
Sulzer, Conrad 24, 47

T
temperance movement 15, 16, 91
Tremont House 41, 46, 61, 73, 101
Truth, Sojourner 19

U
Underground Railroad 55

V
Van Osdel, John M. 43
Volk, Kyle G. 52

W
Wade, Richard C. 29
Wells, Damon 58
Wentworth, John 32, 45, 93, 95
Whig Party 67
Wigwam, the 99
Wittke, Carl 13, 24
women's rights convention 15

Z
Zucker, A.E. 12

ABOUT THE AUTHORS

Chicago native JOHN F. HOGAN is a published historian and former broadcast journalist and on-air reporter (WGN-TV/Radio) who has written and produced newscasts and documentaries specializing in politics, government, the courts and the environment. As WGN-TV's environmental editor, he became the first recipient of the United States Environmental Protection Agency's Environmental Quality Award. His work also has been honored by the Associated Press. Hogan left broadcasting to become director of media relations and employee communications for Commonwealth Edison Company, one of the nation's largest electric utilities. Hogan is the author of Edison's one-hundred-year history, *A Spirit Capable*, as well as three Chicago histories: *Fire Strikes the Chicago Stock Yards*, *Forgotten Fires of Chicago* and *The 1937 Chicago Steel Strike*. He holds a BS in journalism/communications from the University of Illinois at Urbana–Champaign and presently works as a freelance writer and public relations consultant.

About the Authors

Judy E. Brady's assignments with Rotary International, the worldwide service organization, have taken her to Munich, New Delhi and numerous other locales where she has produced stage activities attended by delegates from virtually every nation on the globe. Prior to joining Rotary, she was *Forbes* magazine's Chicago advertising sales operations manager, as well as the head of her own education and hospitality consulting firm. Brady grew up in northeast Indiana, but as a young woman she moved to Chicago, where she became fascinated by the city's rich history, as well as its architecture and cultural life. She attended Roosevelt University, majoring in sociology and public administration. Brady was appointed to the Illinois Commission on the Status of Women's Education subcommittee, was active in the civil rights and women's movements and created a coalition comprising American Association of University Women (AAUW), Illinois Parent Teachers Association (PTA) and Illinois NOW to sponsor legislation with guidelines and enforcement of nondiscriminatory education. Brady and her husband, John F. Hogan, reside in Chicago's East Lakeview community.